CELEBRATING

BIRDS

CELEBRATING
BIRDS

An

INTERACTIVE FIELD GUIDE

Featuring Art from

WINGSPAN

Natalia Rojas & Ana María Martínez,

Illustrators of the Wingspan Board Game

AND THE CORNELL LAB OF ORNITHOLOGY

HARPER
DESIGN
An Imprint of HarperCollins Publishers

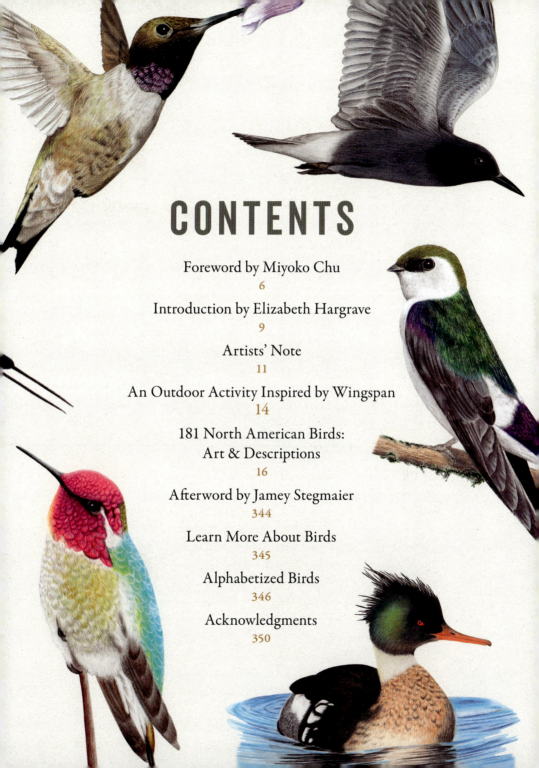

CONTENTS

FOREWORD

In this book, you will encounter a collection of 181 birds, each with a story to tell—stories to intersect with your own journey with birds. I can recall a time when I was oblivious to birds—and also the time afterward, when the world of birds around me opened up as if by magic. It's a common transformation. Many birdwatchers can recount how a "spark bird" led them to notice the next bird and the next (as well as other amazing wildlife), right outside their door and in all the many places where they have looked ever since.

Spark moments can occur unexpectedly, anywhere, any time. One colleague recalls being home sick from kindergarten when an American Redstart appeared outside his window. He identified it from a field guide and became mesmerized by all the beautiful species in the book, sparking a lifelong quest to see them. Another coworker remembers, as a child, scooping up a bird that had been struck by a car and looking into its eyes. "It was like holding a whole living world in my hands," she said. The bird—a White-throated Sparrow—didn't make it, but the experience awakened an interest that led to her career today: weaving birds into curricula for kids across the hemisphere.

My spark birds were pigeons that my dad and I rescued from a poultry truck in San Francisco's Chinatown when I was eleven. We built a coop in our urban backyard, and I spent hours watching them raise their young while I dreamed of becoming a field biologist. My encounters with birds accumulated over decades, taking on richer layers over time. There was the Turkey Vulture my childhood friend pointed out as it soared over a highway; the Cliff Swallow I held after it had returned to Nebraska from a winter in Argentina during my first job as a field assistant; my first sighting of a Phainopepla, with its glossy black plumage and fiery red eye, perched atop a palo verde tree in the desert where I spent six years, studying this species and delighting in the sights and sounds of desert birds. I'll never forget the liquid songs of Canyon Wrens echoing off rock cliffsides, a Common Nighthawk camouflaged on gravel, or a Costa's Hummingbird flying daredevil arcs from sky to ground and back, its high-pitched whistle coming from a tiny blur too fast to be seen.

Wherever you are in your own journey with birds, I hope that this book—and the Wingspan outdoor game (see page 14)—will become part of your story. In these pages, you can encounter dazzling North American birds; then you can take

your book outside and challenge yourself, your friends, and family, to find the birds pictured. There are about eight hundred breeding bird species in North America— if you keep looking and listening for birds, you'll collect countless surprising and memorable moments.

The illustrations in *Celebrating Birds*, by Ana María Martínez and Natalia Rojas, come to you from Wingspan, the celebrated board game designed by Elizabeth Hargrave. The accompanying text is from the Cornell Lab of Ornithology, one of the sources Elizabeth used when creating the game. From the beginning, demand for Wingspan has outstripped the limited supply, new games selling out each time a shipment reaches the shelves. If that popularity is a sign not just of a rewarding game but also of a widespread and growing love of birds, it gives me hope for the future of our planet—despite what looks like an otherwise dismal trajectory.

In 2019, scientists at the Cornell Lab and six other institutions revealed that nearly three billion breeding birds have been lost from the United States and Canada since 1970. More than one in four birds has vanished in my lifetime. Just fifty years ago, we would have heard so many more birds singing. We would have seen more at our feeders, in our neighborhoods, and in the tapestry of landscapes across our hemisphere.

Anyone who has been touched by birds recognizes how impoverished our world would be without them. It's not just their breathtaking beauty and diversity that we would miss. More ominously, when birds disappear in such massive numbers, it means that something is terribly wrong with our environment. Close to home and across the thousands of miles birds travel, they are encountering formidable and escalating hazards, which are taking a devastating toll.

Life is tough for a bird, even without humans adding to the perils they face. Consider the nest of a Bobolink hidden in the grass, vulnerable to snakes, crows, and other predators. A young Bobolink, if lucky enough to fledge, must find food, evade hawks, survive storms, and journey twelve thousand miles to South America and back before it is a year old.

Now add in the human perils and consider how vanishingly small the young bird's chances seem. Songbirds, normally guided by stars as they migrate at night, are pulled toward the lights of cities, where lawns and asphalt offer little food or shelter. It's estimated that, each year, up to a billion birds in this country and Canada are killed by window collisions, and more than 2.6 million are killed by cats.

If our Bobolink beats the tall odds to reach its winter home in Argentina or Bolivia, new threats await. Seen as a pest of rice crops, it may be shot, poisoned, or

trapped and sold as a cage bird. If it survives the flight back to North America, it may mate and build a nest, only to see a mower come to harvest hay, destroying the eggs or young in its path.

Scientists say that one factor takes a bigger toll than any other: habitat destruction. With agricultural intensification and the loss of native grasslands, 720 million grassland birds—53 percent of these populations—have vanished from North America since 1970. Aerial insectivores—birds like swallows, nighthawks, and flycatchers—are down by 32 percent. Forests across the continent contain one billion fewer birds. Even Dark-eyed Juncos, common feeder birds, are down by 139 million.

There are glimmers of hope. Birds are resilient when given a chance. There are thirty-five million more waterfowl and fifteen million more raptors today than in 1970, thanks to conservation efforts that set aside and/or restored habitats and banned the harmful pesticide DDT.

We also have powerful new ways to help birds by transforming observations from thousands of birdwatchers into data needed for vital decision-making. Imagine a world where cell phones light up during peak migration, alerting cities to turn off lights and wind turbines to power down as birds pass through; where farmers get notifications to mow after Bobolinks and meadowlarks have fledged; or where nations decide together which hot spots to protect for migrating shorebirds, songbirds, or raptors. That future could come soon if birdwatchers like you keep contributing observations.

You can also be a voice to support policies that protect birds and habitats needed by wildlife *and* people. And you can bring birds back on a local level by creating a bird-friendly yard, keeping cats indoors, and making windows safer. See page 345 to learn how you can join these and other efforts to help birds.

However you choose to engage with them, I wish you a lifetime of joy and inspiration with birds. I think back to my spark birds of years ago and all the miraculous moments since then, right up until yesterday, when I found a blue eggshell beneath a crabapple tree—a sign that there must be new life in a robin nest, even though it's April and the leaves still haven't unfurled here in the Northeast. The magic awaits. Keep looking.

—Miyoko Chu, Senior Director of Communications, Cornell Lab of Ornithology

INTRODUCTION

I have always loved games. My parents tolerated my love of Candyland, Sorry, and War, then taught me better games like hearts. High school brought epic battles of Egyptian rat screw and gin rummy. In college I played countless games of spades and Scrabble in the kitchen of my group house. In 2005, I discovered hobby board games like Carcassonne and Catan, and there was no looking back. Games gave my brain satisfying little puzzles to work on, whereas the problems I worked on in health policy analysis often felt endless and unsolvable. Games give us something to do while we're doing the thing we really want, which is to be together.

Being outdoors is something else I have always done with friends and family, and birds have long been part of that. My mother taught me the cardinals and the chickadees that came to the feeder and the whip-poor-wills and bobwhites we heard calling as I fell asleep at night. Later, when we moved to Florida, I fell in love with the big waterbirds. The majestic Great Blue Herons and Sandhill Cranes, who seem too big even to fly. The ibis and Roseate Spoonbills, whose ridiculous beaks are wonders of evolution. Birds remind us that there are forces much larger than our tiny lives at work in the world.

But I was in my thirties before I really considered myself either a gamer or a birder. Eventually I developed a set of close friends with shared interests in both the outdoors and games. We'd go canoeing together one weekend and play 7 Wonders the next—connecting with each other and stretching our brains. In retrospect, the spark moment for Wingspan feels almost inevitable: someone in that crowd asked, "Why are there no board games about the things we actually care about?" We were playing games about building castles and spaceships, cutting down trees, and mining ore. I started thinking about how we could, instead, play economic games that model systems in nature.

The first draft of what would become Wingspan consisted of just some handwritten cards. I played by myself until something kind of worked. I played with friends, tweaked, and played some more. I found a community of other board-game designers spread out between Washington, DC, and Baltimore and playtested even more with them.

It was a years-long, iterative process. After more than a hundred tests, I felt I had something ready to pitch to a publisher. With Jamey Stegmaier, president of

Photo courtesy of Kim Euker.

Stonemaier Games, I went on to spend another year or so developing the game further. He'd give me some feedback, then I'd go off and playtest, tweak, and send him a new version.

Among our primary aims was to create a system that makes players feel like they're not just building a set of pretty birds, but that their turns are becoming better and better over the course of the game. What started with some special powers on a few birds, like the Brown-headed Cowbird and the raptors, turned into actions vested in nearly every card. Upgrades to a player's habitats, which used to require investments, became automatic as you played. I also grew the deck of cards from an initial fifty birds to the 170 that finally ended up in the game. Now, with expansion packs, there are even more.

It was amazing to see the illustrations come in from Natalia and Ana—even more so to see them collected and reproduced here, in much more detail than can fit on a playing card.

One of the great joys of Wingspan has been watching my two worlds collide: I have heard from gamers who are becoming birders, and from birders who have become gamers. Ironically, though Wingspan is a game about nature, it's hard to play it *in* nature: the cards inevitably get blown around. So, for this book, we've come up with a game that can be played outside, even on the move—and with real live birds. Inspired by the structure and mechanics of Wingspan, this new outdoor game is simple and easy to learn. I wanted anyone to be able to play, not just those who know how to play the board game. I hope this outdoor game will further my goal of helping to bring the worlds of birders and gamers together. Enjoy!

—Elizabeth Hargrave, Game Designer of Wingspan

ARTISTS' NOTE

Our friendship, and the beginning of our Wingspan flight, began in the very beautiful city of Medellín, Colombia. We were both in high school; we bonded over a love of art and music and shared a good sense of humor. After we graduated, we maintained our friendship as best we could and promised each other always to remain in touch.

Our lives took us in very different directions at first: for Natalia, motherhood in the United States, and for Ana, art school and teaching in Colombia. We fell in and out of touch but always checked in with each other as we traveled our separate paths. Art was often the reason we reconnected over the years. Ana started Nature Canvas, a company that specialized in nature and animal drawings, and enlisted Natalia to help expand it into the United States. We loved working on illustrations together and grew as artists and friends.

A chance meeting in 2017, at a park in St. Louis, Missouri, would change both our lives and reunite us for good. While Natalia's two daughters played in the park, she began chatting with another parent, Alan Stone. Alan turned out to be the cofounder of Stonemaier Games. They started talking about art canvases, and Alan suggested that they might work together on a new board game about birds called Wingspan. He then connected us with Jamey Stegmaier, the president and cofounder of Stonemaier.

Jamey wanted to test our skills in digital illustration, so he asked us to draw the Marsh Wren. The exercise allowed us to demonstrate our abilities in scientific drawing, digital imaging, drawing and processing, editing, sizing and resolution, reformatting for export, and more.

In September of 2017, we received and accepted an offer from Jamey to work on Wingspan. At first, the project was to draw 160 birds. It seemed like a dream come true. We probably didn't realize the challenges and hard work that lay ahead, but we were both so excited about Wingspan and especially about the chance to work together.

Elizabeth Hargrave, the game designer of Wingspan helped us plan the drawings by providing the scientific and common name of each bird, plus a short description. Natalia conducted a thorough search for the best American bird photographers and sought permission to reference their images in executing our drawings.

With all the tools and information we needed to get started, we set out on this marvelous flight. We felt like Andean Condors—Wingspan depicts the California species, but these giant raptors inhabit South America as well—soaring, diving, circling, and reaching new heights in an immense and limitless sky. Life's many responsibilities sometimes impeded our flight: Natalia was the mom of two small daughters, and Ana was busy finishing her thesis. The project took a lot of time, juggling, and sacrifice, but we were both committed to making the art for Wingspan the best it could be. We wanted players of the game to see our beautiful drawings and be inspired to learn more about nature and birds.

In December of 2017, we reunited in Colombia to work on the drawings. Our work space quickly became a lab for trial and error. As we collaborated, we learned so much from each other at a technical level. Christmastime in Colombia is very festive, and we had to forgo many invitations from friends and family for dinners, parties, and dancing. But we were happy to settle for empanadas in the park so we could focus on work.

It took us six months to complete the 170 birds in the base game (we were originally assigned 160, but the number gradually grew during that time). Some birds took eight hours, others thirty-six. We used colored pencils on Bristol 270 g cardboard. For some drawings, we used a scalpel to remove color and generate light in specific areas.

Not every bird was drawn from a single photograph. As Elizabeth explained, the game required that certain characteristics of each bird be included in the illustration; to achieve this, we had to fuse elements from several photographs. In this way, we were able to draw the Ferruginous Hawk, Red-shouldered Hawk, Purple Gallinule, Peregrine Falcon, and American Woodcock, among others. Achieving iridescence was also difficult. We tried metallic colors and markers but failed. After many tries, we found that it worked best to focus on managing light and shadow. We used these techniques for the Northern Shoveler, Wood Duck, Tree Swallow, Purple Martin, and others.

That December, we had no idea of the success that Wingspan would have. We were just happy to be working together on something we were passionate about. Our understanding of what an incredible opportunity this project was for us changed radically when the game went on sale a year later, at the end of 2018. The Wingspan "boom" started in 2019, its popularity soaring on social media as fans of table games, and even nonfans, grew to love Wingspan.

Our names began to circulate in reviews and articles. We were featured in *Smithsonian* magazine, the *New York Times*, and *BirdWatching*, and were interviewed for the websites GreenHookGames, Girls' Game Shelf, Board Game Atlas, and *Mepublice*, and for St. Louis Public Radio. Some local Colombian media outlets covered our story. Additionally, Jamey asked us to create ten more bird illustrations for the swift promo pack for easy learning how to play the game. The Audubon Center at Riverlands, in Missouri, held an exhibition of a hundred of our illustrations, which opened in November 2019 and ran for more than two months. In 2019, Wingspan received the German Kennerspiel des Jahres award as the best board game of the year. We are so proud and joyful to have contributed to the success of the game and the team.

Wingspan deeply transformed our lives. Not only did we grow as professional artists, but our work has reached an international audience. Most important, our appreciation and love for birds as living beings reached new heights. Birds are now such a beautiful and important part of our daily lives. Natalia has built a series of feeders, and she and her daughters photograph and identify the birds that fly into their garden. Ana has taken up professional photography to better identify and study the birds she draws.

When HarperCollins contacted us about publishing a book inspired by Wingspan and featuring our art, we felt that we'd acheived more than everything we had ever dreamed of. If someone had told those two high-school girls in Medellín what they would be today—professional artists and now authors—they would have been very proud.

We hope that *Celebrating Birds* will help you engage with the natural world and that you enjoy these birds as much as we enjoyed creating them. To the people who have made this project possible: thank you. We can't wait to see where this incredible flight continues to take us.

—Natalia Rojas and Ana María Martínez

Translated from Spanish by Professor Joseph Schraibman, Washington University in St. Louis

llustration by Natalia and Ana María

AN OUTDOOR ACTIVITY
Inspired by
WINGSPAN

Take your book out into nature with your friends or family and spot birds to get points!

Rules

1. Get points by IDing birds in nature, and earn extra points based on their habitat, food, and nests that you spot.

2. A different bird must be identified for each of the 9 categories.

3. Earn more points by progressing left to right in each of the 3 rows.

4. The first person to reach 10 points wins.

ALTERNATIVE WAY TO PLAY / *Indoor Option*

Race to name birds that fit in the 9 categories, without spotting them outside.

ROW 1	ID a bird that can live in Forest 1 POINT	ID a bird that eats invertebrates 2 POINTS +1 pt if you actually see it eating an invertebrate	ID a bird that uses a cavity nest 3 POINTS +2 pts if you actually see it go to its nest
ROW 2	ID a bird that can live in Grassland 1 POINT	ID a bird that eats seeds/fruit 2 POINTS +1 pt if you actually see it eating seeds/fruit	ID a bird that uses a ground nest 3 POINTS +2 pts if you actually see it go to its nest
ROW 3	ID a bird that can live in Wetland 1 POINT	ID a bird that eats fish/mammals 2 POINTS +1 pt if you actually see it eating fish/mammals	ID a bird that uses a platform nest 3 POINTS +2 pts if you actually see it go to its nest

CHOOSE FROM ONE OF THE FOLLOWING BONUSES

Photographer: 1 point for each bird with a color in its name

Historian: 1 point for each bird named after a person

181

NORTH AMERICAN
BIRDS

Art & Descriptions

BLACK-BELLIED WHISTLING-DUCK

The Black-bellied Whistling-Duck is a boisterous duck with a brilliant pink bill and an unusual, long-legged silhouette. Common south of the United States, the Black-bellied Whistling-Duck occurs in several southern states, and its range is expanding northward. In places like Texas and Louisiana, watch for noisy flocks of these gaudy ducks dropping into fields to forage on seeds or loafing on golf course ponds. Listen for them, too—these ducks really do have a whistle for their call.

Dendrocygna autumnalis	**ORDER** **ANSERIFORMES**	**FAMILY** **ANATIDAE / DUCKS, GEESE & WATERFOWL**

Cool **FACT**

The whistling-ducks were formerly known as tree ducks, but only a few, such as the Black-bellied Whistling-Duck, actually perch or nest in trees.

BRANT

The Brant is an abundant small goose of the ocean shores, especially in sheltered areas such as bays, lagoons, and inlets, where there is an abundance of aquatic vegetation, their main food. It breeds in the high Arctic tundra and winters along both coasts. Brant found along the Atlantic have light gray bellies, while those of the Pacific coast have black bellies; this population was once considered a separate species.

Wintering locations are usually characterized by an abundance of native intertidal plants used as forage, particularly the seagrass, *Zostera*; no other species of goose relies so heavily on a single plant species during the nonbreeding season.

Cool **FACT**

The oldest recorded Brant, a female, was more than twenty-seven years and six months old. She had been banded in Alaska and was found in Washington.

Branta bernicla

ORDER
ANSERIFORMES

FAMILY
ANATIDAE / DUCKS, GEESE & WATERFOWL

CANADA GOOSE

The big, black-necked Canada Goose with its signature white chinstrap mark is a familiar and widespread bird of a broad range of habitats in temperate to low-arctic regions, including flat tundra, boreal forest, prairies and parklands, high mountain meadows, marshes, bogs, meadows, croplands, golf courses, and athletic fields. Thousands of "honkers" migrate north and south each year, filling the sky with long V formations. But as lawns, golf courses, and playing fields have proliferated, more and more of these grassland-adapted birds are staying put year-round in urban and suburban areas, where some people regard them as pests.

At least eleven subspecies of Canada Goose have been recognized, though only a couple are distinctive. In general, the geese get smaller as you move northward and darker as you go westward. The four smallest forms are now considered a different species: the Cackling Goose.

Branta canadensis

ORDER

ANSERIFORMES

FAMILY

ANATIDAE / DUCKS, GEESE & WATERFOWL

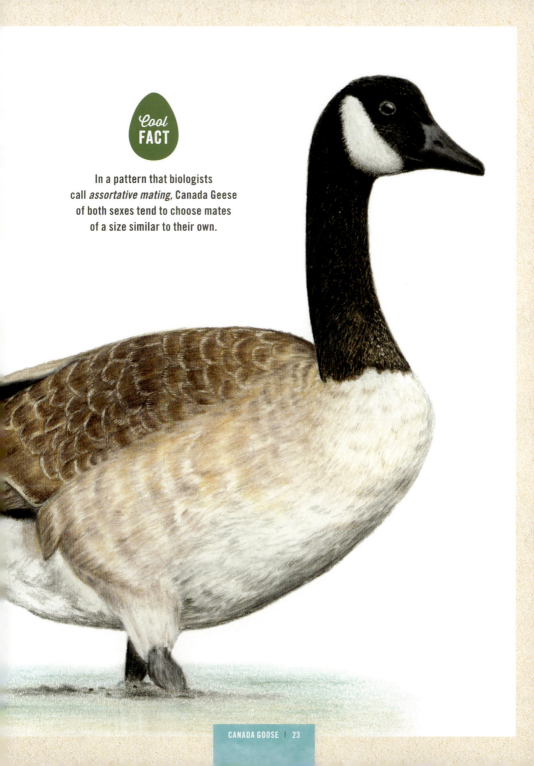

In a pattern that biologists call *assortative mating,* Canada Geese of both sexes tend to choose mates of a size similar to their own.

TRUMPETER SWAN

Trumpeter Swans demand superlatives: they're our biggest native waterfowl, attaining six feet in length and weighing more than twenty-five pounds—almost twice the average weight of a Tundra Swan. It is North America's heaviest flying bird. To get that much mass airborne, the swans need at least a 328-foot "runway" of open water: running hard across the surface, they almost sound like galloping horses as they generate speed for takeoff.

Despite its size, this once-endangered, now recovering species is as elegant as any other swan, with a graceful neck and snowy white plumage. These swans breed on wetlands in remote Alaska, Canada, and the northwestern United States and winter on ice-free coastal and inland waters.

Cygnus buccinator

ORDER
ANSERIFORMES

FAMILY
ANATIDAE / DUCKS, GEESE & WATERFOWL

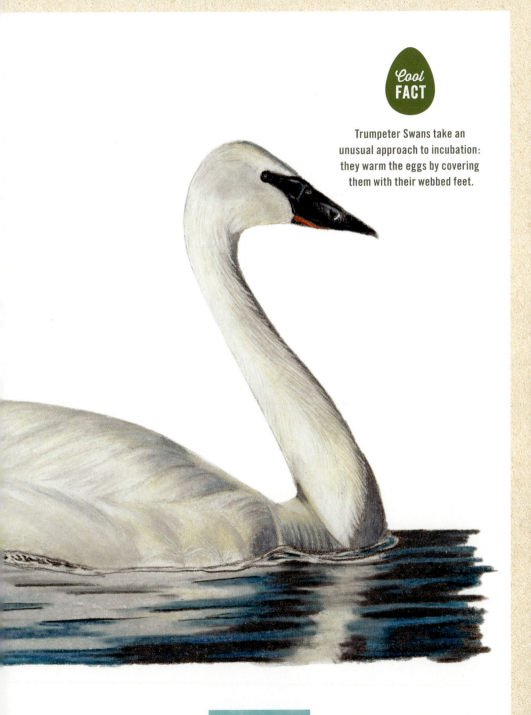

Trumpeter Swans take an unusual approach to incubation: they warm the eggs by covering them with their webbed feet.

WOOD DUCK

The Wood Duck is one of the prettiest of all waterfowl. Males are iridescent chestnut and green with ornate patterning on nearly every feather; the elegant females have a distinctive profile and a delicate white pattern around the eye. These birds live in wooded swamps, where they nest in tree cavities or in nest boxes put up around lake margins. They are among the few duck species equipped with strong claws, which help them grip bark and perch on branches.

Natural cavities for nesting can be scarce, and Wood Ducks readily use nest boxes provided for them. Females may lay eggs in the nests of other females, a phenomenon sometimes called "egg dumping." Many other species of duck also lay their eggs in nests that are not their own, as do South American rheas and some gallinaceous (chickenlike) birds.

Aix sponsa

ORDER

ANSERIFORMES

FAMILY

ANATIDAE / DUCKS, GEESE & WATERFOWL

Cool
FACT

The Wood Duck nests in trees near water—
sometimes directly over water but in some cases
more than a mile away. After hatching, the ducklings
jump down from the nest tree and make their way
to water. The mother calls them to her but does
not help them in any way. Ducklings may jump from
heights of fifty feet or more without injury.

MALLARD

If someone at a park is feeding bread to ducks, chances are that Mallards will be in the fray. Perhaps the most familiar of all ducks, the Mallard occurs throughout North America and Eurasia, in ponds and parks as well as wilder wetlands and estuaries. The male's gleaming green head, gray flanks, and black tail curl make it the most easily identified duck. The standard duck's quack is the sound of a female Mallard. Males don't quack; they make a quieter, rasping sound. Mallards have long been hunted for the table.

If you have a pond or marshy area on your property, Mallards might be attracted to your backyard. Occasionally, Mallards have been known to show up in people's swimming pools.

Anas platyrhynchos	**ORDER** ANSERIFORMES	**FAMILY** ANATIDAE / DUCKS, GEESE & WATERFOWL

Cool FACT

The Mallard is the ancestor of nearly all domestic duck breeds (except the Muscovy Duck).

NORTHERN SHOVELER

Perhaps the most physically distinctive of the dabbling ducks thanks to its large, spoon-shaped bill, the Northern Shoveler busily forages head down in shallow wetlands. That uniquely shaped bill has comblike projections along its edges, which filter tiny crustaceans and seeds from the water. If the bill doesn't catch your eye, the male's striking color palette—bright white chest, rusty sides, and a green head—surely will. The female is no less visually interesting, with a giant orange bill and mottled brown plumage.

Northern Shovelers are monogamous, remaining together longer than most other dabbling duck pairs. Males and females form bonds on their wintering grounds and stay together until just before the fall migration.

Spatula clypeata	ORDER ANSERIFORMES	FAMILY ANATIDAE / DUCKS, GEESE & WATERFOWL

Cool FACT

When flushed off the nest, a female Northern Shoveler often defecates on her eggs, apparently to deter predators.

CANVASBACK

Among the most distinctly shaped of American duck species, the Canvasback sports a long, sloping forehead and long bill. Its name comes from the fine barring on the pale back, which looked to early European settlers like canvas fabric. Males stand out, with a rusty head and neck and a gleaming whitish body bookended in black. Females are pale brown overall, but that Canvasback head shape signals their identity. This diving duck eats plant tubers at the bottom of lakes and wetlands. It breeds in lakes and marshes, and winters by the thousands on freshwater lakes and coastal waters.

The species name of the Canvasback, *valisineria*, comes from *Vallisneria americana*, or wild celery, whose winter buds and stems are the duck's preferred food during the nonbreeding period.

Aythya valisineria	**ORDER** ANSERIFORMES	**FAMILY** ANATIDAE / DUCKS, GEESE & WATERFOWL

Cool **FACT**

In the world of ducks, females abide by the saying, "Don't put all your eggs in one basket." Female Canvasbacks sometimes lay eggs in another's nest, and Redheads and Ruddy Ducks (page 39) sometimes lay their eggs in a Canvasback's nest.

Cool
FACT

Barrow's Goldeneye is potentially long-lived for a duck, with a maximum reported longevity of 18 years in the wild. Once the ducklings leave the nest, several different broods come together and are parented by a single female. The young ducklings are highly independent, however, and require little parental care.

BARROW'S GOLDENEYE

Mostly a bird of wild northwestern landscapes, the Barrow's Goldeneye is a striking, medium-sized diving duck. Males are outfitted in crisp black and white, with a purplish head, a long white crescent on the face, and a row of white "windows" along the shoulder. Females are cool gray, their heads colored a rich brown and usually bearing a mostly orange-yellow bill.

These ducks nest in tree cavities (or in nest boxes) in remote boreal and montane forests—often using old nests of Northern Flickers (page 180) or Pileated Woodpeckers (page 181). In winter and spring, males gather around females to perform acrobatic courtship displays.

Bucephala islandica	**ORDER** **ANSERIFORMES**	**FAMILY** **ANATIDAE / DUCKS, GEESE & WATERFOWL**

HOODED MERGANSER

"Hooded" is an understated description of this extravagantly crested little duck. Adult males are a sight to behold, with sharp black-and-white patterns set off by chestnut flanks. Females derive their own distinctive beauty from a cinnamon crest. Hooded Mergansers are fairly common on small ponds and rivers, where they dive for fish, crayfish, and other food, seizing it in their thin, serrated bills. They nest in tree cavities.

Hooded Mergansers find their prey underwater by sight. Hooded Merganser ducklings leave their nest cavity within twenty-four hours of hatching. Their mother first checks the area around the nest, then calls to the nestlings from ground level. The little fluffballs scramble up to the entrance hole and flutter to the ground, which may be fifty feet or more below them. With a bold leap to the forest floor, they depart the nest. They may need to walk half a mile or more with their mother to reach the nearest body of water.

Lophodytes cucullatus	**ANSERIFORMES**	**ANATIDAE / DUCKS, GEESE & WATERFOWL**

Cool FACT
Hooded Mergansers can actually control the refractive (light-bending) properties of their eyes to improve their underwater vision. They also have a transparent extra eyelid, called a "nictitating membrane," which helps protect the eye during swimming, like a pair of goggles.

COMMON MERGANSER

The Common Merganser is a streamlined duck that floats gracefully down rivers or shallow shorelines. The handsome male has a clean white body with black on top, a dark green head, and a slender, serrated red bill. The gray-bodied female sports a short crest on her reddish brown head. In summer, look for females leading ducklings from eddy to eddy along streams or standing on a flat rock in the middle of the current. These large ducks nest in hollow trees; in winter they form flocks on larger bodies of water.

Young Common Mergansers leave their nest hole within a day or so of hatching. The flightless chicks leap from the nest entrance and tumble to the forest floor. The mother protects the chicks, but they catch all of their own food—starting by diving for aquatic insects and switching over to fish when about twelve days old.

Mergus merganser	**ORDER** ANSERIFORMES	**FAMILY** ANATIDAE / DUCKS, GEESE & WATERFOWL

Cool
FACT

Common Mergansers usually nest in natural
tree cavities or holes carved out by large woodpeckers.
They may take up residence in nest boxes,
provided the entrance hole is large enough. They
have been known to use rock crevices, holes in the ground,
hollow logs, old buildings, and chimneys.

RED-BREASTED MERGANSER

A shaggy-headed diving duck, the Red-breasted Merganser is also known as the sawbill: its thin bill has tiny serrations that help the duck keep hold of slippery fish. It breeds in the boreal forest on freshwater and saltwater wetlands. Males are decked out with a dark green, crested head, a red bill and eye, and a rusty chest. Females lack the male's bright colors but share the same disheveled 'do.

Red-breasted Mergansers parade around coastal waters and large inland lakes in the United States and Mexico in the winter and have an enthusiastic and graceful diving style. In winter and spring, males gather in groups to perform animated courtship displays to females, pointing the bill up to the sky and making a catlike call, then dunking the breast and raising just the head out of the water and calling again.

Mergus serrator	ORDER **ANSERIFORMES**	FAMILY **ANATIDAE / DUCKS, GEESE & WATERFOWL**

Cool **FACT**

Red-breasted Mergansers need to eat fifteen to twenty fish per day. To meet their energy needs, research suggests, they need to dive underwater 250 to 300 times or forage for four to five hours per day.

RUDDY DUCK

Ruddy Ducks are compact, thick-necked waterfowl with tails that seem oversized, habitually held upright. Breeding males are almost cartoonishly marked, with a sky blue bill, shining white cheek patch, and glossy chestnut body. They court females by beating their bill against their neck hard enough to create a swirl of bubbles in the water. This widespread duck breeds mostly in the prairie pothole regions of North America and winters in wetlands throughout the United States and Mexico.

Ruddy Ducks lay big, white, pebbly textured eggs—the largest of all duck eggs relative to the bird's body size. Although the female must expend much energy incubating her eggs, they hatch into well-developed ducklings that require only a short period of care.

Oxyura jamaicensis	**ORDER** **ANSERIFORMES**	**FAMILY** **ANATIDAE / DUCKS, GEESE & WATERFOWL**

Cool **FACT**

Pleistocene fossils of Ruddy Ducks, at least eleven thousand years old, have been unearthed in Oregon, California, Virginia, Florida, and Illinois.

SCALED QUAIL

Flocks of Scaled Quail scurry through the desert grasslands of the southwestern United States, calling softly to each other to stay in contact. These attractive, brownish gray game birds have an understated crest with a buffy top, and on the breast and belly a marvelous pattern of dark brown and gray-buff. When they encounter people or predators, the birds dash away through the brush or else fly a short distance and reassemble. In spring, males perch in the open on a bush or fence post, singing a short, hoarse *whock* note to attract a mate.

The white crest gives the Scaled Quail its colloquial name of cottontop. It is also called the blue quail because of its bluish gray breast and back. "Scaled" refers to a pattern of feathers that overlap like fish scales.

Callipepla squamata	**ORDER** **GALLIFORMES**	**FAMILY** **ODONTOPHORIDAE /** **NEW WORLD QUAIL**

Cool FACT

Like other small quail that live
in coveys, Scaled Quail form a circle,
facing outward, to sleep at night.

CALIFORNIA QUAIL

A handsome, round soccer ball of a bird, the California Quail has a rich gray breast, intricately scaled underparts, and a curious, forward-drooping head plume. Its stiffly accented *Chi-ca-go* call is a common sound of the chaparral and other brushy habitats of California and the Northwest. Often seen scratching at the ground in large groups or dashing forward on blurred legs, California Quail are common but unobtrusive. They flush toward brushy areas for cover if scared, so approach them gently.

California Quail are pretty to observe as well as popular with game hunters. They've been introduced to many other parts of the world, including Hawaii, Europe, and New Zealand.

Callipepla californica	**ORDER** **GALLIFORMES**	**FAMILY** **ODONTOPHORIDAE / NEW WORLD QUAIL**

Cool **FACT**

The California Quail is California's state bird and has had roles in several Disney movies, including *Bambi*.

NORTHERN BOBWHITE

An emphatic, whistled *bob-white!* ringing from a grassy field or piney woods has long been a characteristic sound of summer in the eastern countryside. It's quite a bit harder to spot a Northern Bobwhite than to hear one, as the bird's dappled plumage offers excellent camouflage. Bobwhites forage in groups, scurrying between places of cover or bursting into flight if alarmed. The species has been in sharp decline throughout the past half century, likely owing to habitat loss and changes in agriculture, and is an increasingly high priority for conservation.

Because of its history as a game bird, the Northern Bobwhite is one of the world's most intensively studied bird species. Scientists have researched the impacts of human activities from pesticide application to prescribed burning on both wild and captive bobwhites.

Colinus virginianus	**ORDER** GALLIFORMES	**FAMILY** ODONTOPHORIDAE / NEW WORLD QUAIL

Cool FACT

Northern Bobwhites were thought to be monogamous until researchers began radio tracking individuals to follow their activities. It turns out that both male and female bobwhites can have multiple mates in one season.

Cool
FACT

The extinct Heath Hen was a subspecies (*T. c. cupido*) of Greater Prairie-Chicken that inhabited the Eastern Seaboard from Maryland to Massachusetts in the colonial era. Excessive hunting of this bird led to restrictions as early as 1791, but declines continued even so. The last Heath Hen died on Martha's Vineyard, Massachusetts, in 1932.

GREATER PRAIRIE-CHICKEN

Few performances in the bird world are more memorable than the dawn display of Greater Prairie-Chickens at their booming ground, or *lek*—the traditional spot where males dance, call, and try to impress females with their vigor. When displaying, males erect earlike plumes on their head and blow up bright orange air sacs on their neck, all the while drumming with their feet and producing whooping and cackling calls. "Booming" refers to the characteristic low-frequency sounds produced by the male's air sacs during territorial displays.

Some leks have been used for more than a century and are considered "ancestral," in contrast to more recently established, unstable "satellite" areas. When prairie-chicken populations are low, most males assemble at ancestral areas, but during periods of higher populations the satellite areas may contain many males (especially younger ones).

Tympanuchus cupido	ORDER GALLIFORMES	FAMILY PHASIANIDAE / PHEASANTS, GROUSE & ALLIES

WILD TURKEY

Many North American kids learn to identify turkeys early, by tracing outlines of their hands to make Thanksgiving cards. These big, spectacular birds are an increasingly common sight the rest of the year, too, flocks striding around woods and clearings like miniature dinosaurs. Courting males puff themselves into feathery balls and fill the air with exuberant gobbling. The Wild Turkey's popularity at the table and widespread destruction and modification of its natural habitat between 1850 and 1970 led to a drastic decline in numbers, but populations have increased in many regions, often as a result of releases of captive-bred turkeys, and the species now occurs in every state except Alaska— even in Hawaii, where it has been introduced.

Because of their large size, compact bones, and long-standing popularity as a dinner item, turkeys have a better fossil record than most birds. Turkey fossils have been unearthed across the southern United States and Mexico, some of them dating from more than five million years ago.

Meleagris gallopavo	ORDER GALLIFORMES	FAMILY PHASIANIDAE / PHEASANTS, GROUSE & ALLIES

Cool FACT

When they need to, Wild Turkeys can swim by tucking their wings in close, spreading their tails, and kicking with their powerful feet.

COMMON LOON

The eerie calls of Common Loons echo across clear lakes of the northern wilderness. You can also find them close to shore on most seacoasts and on many inland reservoirs. They are less suited to land, typically coming ashore only to nest. In summer, adults are regally patterned in black and white; in winter, they are plain brown above and white below.

The Common Loon is a powerful, agile diver that catches small fish in fast underwater chases, propelling itself with its feet. It swallows most of its prey underwater; sharp, rearward-pointing projections on its tongue and the roof of its mouth help it keep a firm hold on slippery fish. A hungry loon family can put away a lot of fish: biologists estimate that loon parents and their two chicks (the typical number) can eat about a half ton of fish over a fifteen-week period.

| *Gavia immer* | ORDER **GAVIIFORMES** | FAMILY **GAVIIDAE / LOONS** |

Cool **FACT**

Loons are excellent swimmers, but they move pretty fast in the air, too. Migrating loons have been clocked flying at speeds of more than seventy miles an hour.

PIED-BILLED GREBE

Part bird, part submarine, the Pied-billed Grebe is common across much of North America. These expert divers inhabit sluggish rivers, freshwater marshes, lakes, and estuaries. They have unusually thick bills that turn silver and black in summer, which they use to kill and eat large crustaceans along with a great variety of fish, amphibians, insects, and other invertebrates. Rarely seen in flight and often hidden amid vegetation, the small, brown Pied-billed Grebe announces its presence with loud, far-reaching calls.

The species name for Pied-billed Grebe (*podiceps*) means "feet at the buttocks"—an apt descriptor for these birds, whose feet are indeed located near their rear ends. This body plan, a feature of many diving birds, helps grebes propel themselves through water. Lobed (not webbed) toes further assist with swimming. Pied-billed Grebes pay for their aquatic prowess on land, where they walk awkwardly.

Podilymbus podiceps	ORDER PODICIPEDIFORMES	FAMILY PODICIPEDIDAE / GREBES

Cool FACT

When in danger, Pied-billed Grebes sometimes make a dramatic "crash dive" to get away. A crash-diving grebe pushes its body down while thrusting its wings outward. Its tail and head disappear last, while the bird kicks water several feet into the air.

CLARK'S GREBE

One of North America's two marvelously elegant, black-and-white grebes, the Clark's Grebe is a bird of western lakes and coastlines. Its sinuous neck and angular head give it an almost snakelike air, and its elaborate "rushing ceremony"—a courtship display shared with its close relative, the Western Grebe—can make you imagine that ballet dancers have taken to the water. Search large inland lakes in summer and ocean shores in winter to find this species, which can occur alongside the more numerous and extremely similar Western Grebe.

Aechmophorus clarkii	**ORDER**	**FAMILY**
	PODICIPEDIFORMES	**PODICIPEDIDAE / GREBES**

Cool FACT

Western and Clark's Grebes were considered the same species until 1985. By then, scientists had learned that the two species rarely interbreed (despite sometimes living on the same lakes), make different calls, and have substantially different DNA.

WOOD STORK

The large, white Wood Stork wades slowly through southeastern swamps and wetlands, feeling in the water with its long, hefty bill for fish and crustaceans. This bald-headed, ungainly-looking wading bird stands just over three feet tall, towering above almost all other wetland birds. Groups of Wood Storks often roost in trees, and they nest in colonies, building their nests in trees, usually above standing water. Storks are excellent fliers, often soaring gracefully on thermals (warm, rising air), with neck and legs outstretched. Their soaring ability aids them in locating drying wetlands, where prey is concentrated.

Kids love water parks when it gets hot outside. Nestling birds don't have that option, but to keep their nestlings cool, Wood Stork parents regurgitate water over the young—maybe not as fun as a water park, but it does the trick.

Mycteria americana	ORDER	FAMILY
	CICONIIFORMES	CICONIIDAE / STORKS

Cool FACT

Storks—mainly the White Stork of Africa and Eurasia—figure prominently in mythology. They are revered in Greek, Chinese, and European myths as signs of good luck and harbingers of spring and birth, and in Egyptian mythology, storks represent the *ba* or individual soul, often depicted as a stork with human head. The association between storks and babies was popularized by Hans Christian Andersen in his nineteenth-century fairy tale "The Storks."

DOUBLE-CRESTED CORMORANT

The gangly Double-crested Cormorant is a prehistoric-looking, matte black fishing bird with yellow-orange facial skin. Though these cormorants look like a combination of a goose and a loon, they are relatives of frigatebirds and boobies. A common sight in freshwater and saltwater habitats across North America, they are most visible when they stand on docks, rocky islands, and channel markers, wings spread out to dry. These solid, heavy-boned birds are experts at diving to catch small fish. They lack waterproof feathers, which reduces their buoyancy, enabling them to sink to lower depths more quickly and efficiently; they spread their wings to dry the feathers after swimming.

From a distance, the Double-crested Cormorant is just a dark bird with a snaky neck, but up close it's quite colorful—with orange-yellow skin on its face and throat, striking aquamarine eyes that sparkle like jewels, and bright blue on the inside of its mouth.

Phalacrocorax auritus

ORDER

SULIFORMES

FAMILY

PHALACROCORACIDAE / CORMORANTS & SHAGS

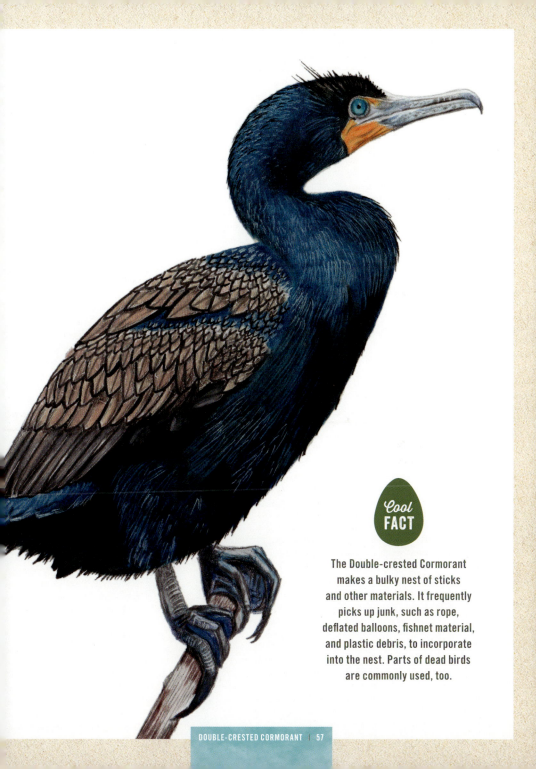

The Double-crested Cormorant makes a bulky nest of sticks and other materials. It frequently picks up junk, such as rope, deflated balloons, fishnet material, and plastic debris, to incorporate into the nest. Parts of dead birds are commonly used, too.

ANHINGA

A dark body swims stealthily through a lake, only its snakelike head poking above the surface. What you're seeing is an Anhinga, which swims underwater and stabs fish with its daggerlike bill. After every dip, it strikes a dramatic pose on the edge of a shallow lake or pond, head held high, and stretches out silvery wings to dry its waterlogged feathers. Once dry, it takes to the sky, soaring high on thermals in a cruciform shape. This bird lives only in the southeasternmost part of the United States as well as many places in Central and South America.

The Anhinga's distinctive looks earned it the nicknames water turkey (for its fanlike tail) and snake bird, for its long, snakelike neck. Unlike most waterbirds, the Anhinga doesn't have waterproof feathers. While that may seem like a disadvantage for its watery lifestyle, wet feathers and dense bones help the birds submerge their bodies under the water to slowly stalk fish.

Anhinga anhinga	**ORDER** SULIFORMES	**FAMILY** ANHINGIDAE / ANHINGAS

Cool **FACT**

The name Anhinga, meaning "devil bird" (an evil spirit of the woods), comes from the Tupi Indians in Brazil, where the species is common.

AMERICAN WHITE PELICAN

One of the largest North American birds, the American White Pelican is majestic in the air, soaring with incredible steadiness on broad, white and black wings. Its large head and huge, heavy bill give the bird a prehistoric look. On the water, pelicans dip their pouched bills to scoop up fish or tip up like an oversized dabbling duck to forage on the bottom. Sometimes groups of pelicans work together to herd fish into the shallows for easy feeding. Look for them on inland lakes in summer and near coastlines in winter.

Pelicans are skillful food thieves. They steal large fish from other pelicans trying to swallow the prey, succeeding on about a third of such attempts. They also try to steal prey from Double-crested Cormorants that are bringing fish to the surface. In their dense nesting colonies, American White Pelicans may even steal the food disgorged by a parent for its young on an adjacent nest.

Pelecanus erythrorhynchos

ORDER
PELECANIFORMES

FAMILY
PELECANIDAE / PELICANS

Cool
FACT

Contrary to cartoon portrayals and common misconceptions, pelicans never carry food in their bill pouches. They use them to scoop up food but swallow their catch before flying off.

BROWN PELICAN

The Brown Pelican is a conspicuous and popular seabird with an oversized bill, a sinuous neck, and a big, dark body. Squadrons glide above the surf along southerly North American coastlines, rising and falling in a graceful echo of the waves. They feed by plunge-diving from high up, using the force of impact to stun small fish before scooping them up. Brown Pelicans are fairly common today—an excellent example of a species' recovery from pesticide pollution that once pushed it to the brink of extinction.

While a Brown Pelican is draining water from its bill after a dive, gulls often try to steal the fish right out of its pouch—sometimes while perching on the pelican's head. Pelicans, too, like a free meal, often begging for handouts around fishing piers or attending active fishing boats in hopes of leftovers.

Pelecanus occidentalis	ORDER PELECANIFORMES	FAMILY PELECANIDAE / PELICANS

Cool FACT

Pelicans incubate their eggs with the skin of their feet, essentially standing on the eggs to keep them warm. Widespread use in the mid-twentieth century of the pesticide DDT caused pelicans to lay thinner eggs that cracked under the weight of incubating parents. After nearly disappearing from North America in the 1960s and 1970s, Brown Pelicans made a full comeback, thanks to pesticide regulation.

AMERICAN BITTERN

You'll need sharp eyes to catch sight of an American Bittern. This streaked, brown and buff heron can materialize among the reeds and disappear as quickly, especially when striking a concealment pose with its neck stretched and bill pointed skyward. These stealthy carnivores stand motionless amid tall marsh vegetation, or patiently stalk fish, frogs, and insects. American Bitterns are heard more often than seen—especially in spring, when the marshes resound with their odd booming calls, which sound like the gulps of a thirsty giant. Those booming, clacking, gulping calls have earned the bird some colorful nicknames, including stake driver, thunder pumper, water belcher, and mire drum.

Botaurus lentiginosus	ORDER **PELECANIFORMES**	FAMILY **ARDEIDAE / HERONS, EGRETS & BITTERS**

Cool FACT

The American Bittern's yellow eyes can focus downward, giving the bird's face a comically startled, cross-eyed appearance. This visual orientation presumably enhances the bird's ability to spot and capture prey. The eyes turn orange during breeding season.

GREAT BLUE HERON

Whether poised at a river bend or cruising a shoreline with slow, deep wingbeats, the Great Blue Heron is a majestic sight. This stately heron with its subtle blue-gray plumage is widespread and highly adaptable, living in marine or freshwater habitats from Alaska to the Caribbean. Great Blue Herons stand motionless to scan for prey or wade belly deep with long, deliberate steps. They may move slowly but can strike like lightning to grab a fish or snap up a gopher. In flight, this heron tucks in its neck and trails its long legs.

Great Blue Herons congregate at fish hatcheries, creating potential problems for the fish farmers. A study found, however, that herons ate mostly diseased fish that would have died anyway. Sick fish spent more time near the surface of the water, where they were more vulnerable to the herons.

Ardea herodias

ORDER
PELECANIFORMES

FAMILY
ARDEIDAE / HERONS, EGRETS & BITTERS

Cool FACT

Despite their impressive
size, Great Blue Herons weigh
only five to six pounds, thanks in
part to their hollow bones—
a feature all birds share.

GREAT EGRET

The elegant Great Egret is a dazzling sight in many a North American wetland. Slightly smaller and more svelte than Great Blue Herons, these are still large birds with impressive wingspans. They hunt in classic heron fashion, standing immobile or wading through wetlands to capture fish or other small prey with a deadly jab of their yellow bill.

Great Egrets were hunted nearly to extinction for their plumes in the late nineteenth century, sparking conservation movements and some of the first laws to protect birds. The Great Egret is the symbol of the National Audubon Society, one of the oldest environmental organizations in North America. The society was founded to protect birds from being killed for their feathers.

| *Ardea alba* | **ORDER** PELECANIFORMES | **FAMILY** ARDEIDAE / HERONS, EGRETS & BITTERS |

Cool FACT

Great Egrets flap their wings slowly but fly powerfully: even at just two wingbeats per second, their cruising speed is around twenty-five miles an hour.

SNOWY EGRET

Among the most beautiful of the herons, the slender Snowy Egret boasts immaculate white plumage set off by black legs and brilliant yellow feet. Those feet seem to play a role in stirring up or herding small aquatic animals as the egret forages.

During the breeding season, adult Snowy Egrets develop filmy, curving plumes on their backs, necks, and heads. In 1886, these plumes were valued at $32 per ounce—twice the price of gold at that time. Plume hunting for the fashion industry killed many Snowy Egrets and other birds until reforms were passed in the early twentieth century. The recovery of shorebird populations through the work of concerned citizens helped give birth to the conservation movement. Thanks to these efforts, *Egretta thula* is once again a common sight in shallow coastal wetlands.

Egretta thula	ORDER **PELECANIFORMES**	FAMILY **ARDEIDAE / HERONS, EGRETS & BITTERS**

Cool FACT

Snowy Egrets sometimes mate with other heron species and produce hybrid offspring. They have been known to hybridize with Tricolored Herons, Little Blue Herons, and Cattle Egrets.

GREEN HERON

From a distance, the Green Heron is a dark, stocky bird, hunched on slender yellow legs at the water's edge, often hidden behind a tangle of leaves. Seen up close, it is striking: a rich chestnut body, velvet green on the back, and a dark cap often raised into a short crest. These small herons crouch patiently to surprise fish and other prey with a dart of their daggerlike bill. They sometimes even lure in fish, using small items such as twigs or insects as bait.

The Green Heron is part of a group of small herons once combined as a single species known as Green-backed Heron. When they are treated as two different species, these are called the Green Heron and the Striated Heron.

Butorides virescens	**ORDER** **PELECANIFORMES**	**FAMILY** **ARDEIDAE / HERONS, EGRETS & BITTERS**

Cool **FACT**

The Green Heron is one of the world's few tool-using bird species. It may create fishing lures with twigs, berries, insects, and feathers, dropping them on the surface of the water to entice small fish.

BLACK-CROWNED NIGHT-HERON

Black-crowned Night-Herons are stocky birds compared with many of their long-limbed heron relatives. They're most active at night or at dusk, when you may see their ghostly forms flapping out from daytime roosts to forage in wetlands. In the light of day, adults are striking in gray and black plumage and long white head plumes. These social birds breed in colonies, where they build bulky stick nests in trees, usually at the water's edge. The world's most widespread heron, the Black-crowned lives in fresh, salt, and brackish wetlands.

The familiar evening sight and sound of the Black-crowned Night-Heron was captured in this description by Arthur Bent in his *Life Histories of North American Marsh Birds*: "How often, in the gathering dusk of evening, have we heard its loud, choking squawk and, looking up, have seen its stocky form, dimly outlined against the gray sky and propelled by steady wing beats, as it wings its way high in the air toward its evening feeding place in some distant pond or marsh!"

Nycticorax nycticorax	ORDER **PELECANIFORMES**	FAMILY **ARDEIDAE / HERONS, EGRETS & BITTERS**

Scientists find it easy, if a bit smelly and messy, to study the diet of young Black-crowned Night-Herons: the nestlings often disgorge their stomach contents when approached.

WHITE-FACED IBIS

A dark wading bird with a long, down-curved bill, the White-faced Ibis is similar in appearance and habits to the Glossy Ibis. The two species can be distinguished only by slight differences in coloring of the face and legs. This species feeds in freshwater wetlands—shallow marshes, wet ditches, and flooded or irrigated cropfields—often in large flocks. The White-faced Ibis is an attractive, long-legged wader with metallic bronze plumage. In the breeding season, adults have distinctive white feathers along the edge of their bare facial skin. The species is locally common, nesting in marshes in the western United States, especially in the Great Basin, and wintering in large flocks in Mexico, southwestern Louisiana, and eastern Texas.

Plegadis chihi	ORDER **PELECANIFORMES**	FAMILY **THRESKIORNITHIDAE / IBISES & SPOONBILLS**

Cool FACT

The oldest recorded White-faced Ibis was banded in Oregon and was at least twelve years and three months old when it was found sick in California. It recovered and was released.

ROSEATE SPOONBILL

The flamboyant Roseate Spoonbill looks as if it came straight out of a Dr. Seuss book, with its bright pink feathers, red eye staring out from a partly bald head, and giant spoon-shaped bill. Groups of these wading birds sweep their spoon-shaped bills through shallow freshwater or saltwater habitats, snapping up crustaceans and fish. They fly with necks outstretched, to and from foraging and nesting areas along the coastal southeastern United States, and south to South America. These social birds nest and roost in trees and shrubs with other large wading birds.

The Roseate Spoonbill is one of six species of spoonbills in the world and the only one found in the Americas. The other five spoonbills (Eurasian, Royal, African, Black-faced, and Yellow-billed) occur in Asia, Africa, Europe, and Australia.

Platalea ajaja	**ORDER** **PELECANIFORMES**	**FAMILY** **THRESKIORNITHIDAE / IBISES & SPOONBILLS**

Cool **FACT**

We humans are all too familiar with age-related hair loss. Roseate Spoonbills, it turns out, experience balding, too, but instead of losing hair as they get older, they lose feathers from the top of their head.

BLACK VULTURE

Sporting sooty black plumage, a bare black head, and neat white stars under their wingtips, Black Vultures are almost dapper. In contrast to the lanky, red-headed Turkey Vulture with its teetering flight, the Black Vulture is a compact bird with broad wings, short tail, and rapid, choppy wingbeats. The two species often associate: Black Vultures make up for their poor sense of smell by following Turkey Vultures to carcasses. Highly social and exhibiting fierce family loyalty, Black Vultures share food with relatives and feed their young for months after they've fledged.

Although Turkey Vultures outnumber Black Vultures in the United States, the latter have a huge range and the largest population of any vulture in the Western Hemisphere.

Coragyps atratus	**ORDER** CATHARTIFORMES	**FAMILY** CATHARTIDAE / NEW WORLD VULTURES

Cool FACT

Black Vultures lack a voice box, so their vocal repertoire is limited to raspy hisses and grunts.

TURKEY VULTURE

If you've gone looking for raptors on a clear day, your heart has probably leaped at the sight of a large, soaring bird in the distance—perhaps an eagle or osprey? But if it's soaring with its wings raised in a V and making wobbly circles, it is more likely to be a Turkey Vulture. These birds ride thermals in the sky and use their keen sense of smell to find fresh carcasses. This vulture is a consummate scavenger. With unfeathered heads and sharp, curved bills, Turkey Vultures are perfectly evolved to devour carrion in very short order, thus cleaning up the countryside of carcasses. The most common time to see a Turkey Vulture is while driving, so look along the sides of highways and in the sky over open countryside. When hiking or traveling in hilly or mountainous areas, keep your eyes peeled for vultures. Sudden changes in topography create updrafts that the birds use to soar skyward.

Cathartes aura	ORDER CATHARTIFORMES	FAMILY CATHARTIDAE / NEW WORLD VULTURES

Cool FACT

Turkey Vultures have an excellent sense of smell. Their close cousin, the Black Vulture, is a much less accomplished sniffer. When a Turkey Vulture detects the delicious aroma of decaying flesh and descends on a carcass, Black Vultures often follow close behind.

CALIFORNIA CONDOR

The spectacular but endangered California Condor is the largest bird in North America. These superb gliders travel widely to feed on carcasses of deer, pigs, cattle, sea lions, whales, and other animals. Pairs nest in caves high on cliff faces. The population fell to just twenty-two birds in the 1980s, but there are now some 230 free-flying birds in California, Arizona, and Baja California, with another 160 in captivity. In 1987, the U.S. Fish and Wildlife Service launched an intensive campaign to rescue the species, but lead poisoning remains a severe threat to their long-term prospects; the condor's diet includes carcasses left by hunters, some of whom still use lead bullets.

In the late Pleistocene, about forty thousand years ago, California Condors were found throughout North America. Back then, giant mammals roamed the continent, providing condors with a reliable food supply. When Lewis and Clark explored the Pacific Northwest in 1805 they found condors. Until the 1930s, the species occurred in the mountains of Baja California. Happily, in 2007, condors reintroduced in Baja California laid their first egg and have been breeding in the San Pedro Mártir Mountains ever since.

Gymnogyps californianus	**ORDER** **CATHARTIFORMES**	**FAMILY** **CATHARTIDAE / NEW WORLD VULTURES**

Cool FACT

Condors can survive one to two weeks without eating. When they find a carcass, they eat their fill, storing up to three pounds of meat in their crop (a part of the esophagus) before they leave.

OSPREY

Unique among North American raptors for its strict diet of live fish and its ability to dive into water to catch them, the Osprey is a common sight on North American coasts. You can spot Ospreys as they soar over shorelines, patrol waterways, and stand on their huge stick nests, white heads gleaming. These large, rangy hawks do well around humans, and their numbers have rebounded since the pesticide DDT was banned. Hunting Ospreys are a picture of concentration, diving with feet outstretched and yellow eyes sighting straight along their talons.

The Osprey readily builds its nest on manmade structures, such as telephone poles, channel markers, duck blinds, and nest platforms designed especially for it. Such platforms have become an important tool in reestablishing Ospreys in areas from which they had disappeared. In some places, the hawks build nests almost exclusively on artificial structures.

Pandion haliaetus	**ORDER** ACCIPITRIFORMES	**FAMILY** PANDIONIDAE / OSPREY

Cool FACT

Ospreys are excellent anglers. As seen in several studies, Ospreys caught fish on at least one in every four dives on average, with success rates sometimes as high as 70 percent. The average time they spent hunting before making a catch was about twelve minutes—something to think about next time you throw your line in the water.

GOLDEN EAGLE

The Golden Eagle is one of North America's largest raptors. Lustrous gold feathers adorn the back of its head and neck; a powerful beak and talons advertise its hunting prowess. You're most likely to see this eagle in western regions, soaring on steady wings or diving in pursuit of the jackrabbits and other small mammals that are its main prey. Sometimes seen attacking large mammals, even fighting off coyotes or bears in defense of its prey and young, the Golden Eagle has long inspired both reverence and fear.

Hacking, an age-old falconry technique, is helping to rebuild Golden Eagle populations. Human caretakers feed caged, lab-reared nestlings at a nestlike hack site until the birds reach twelve weeks of age, at which point the cage is opened and they begin feeding themselves. The fledglings continue to receive handouts for several weeks until fully independent in the wild.

Aquila chrysaetos	ORDER **ACCIPITRIFORMES**	FAMILY **ACCIPITRIDAE / HAWKS, EAGLES & KITES**

Cool FACT

The much-admired Golden Eagle is the national bird of Mexico, Germany, Scotland, and Albania, and many other countries also have eagles as their national bird or symbol.

MISSISSIPPI KITE

The Mississippi Kite makes a streamlined silhouette as it careens through the sky on the hunt for small prey or dive-bombs intruders that come too close to its nest tree. These sleek, pearly gray raptors often hunt together and nest colonially in stands of trees, from windbreaks on southern prairies to old-growth bottomlands in the Southeast and even in developed areas. After the nesting season, both adults and young birds fly all the way to central South America for the winter.

Mississippi Kites have increased in the western part of their range, thanks to recent changes in the landscape, such as shelterbelts planted by farmers and ranchers. Nesting in golf courses and city parks can be problematic, as the kites tend to dive-bomb people who unwittingly come too close.

Ictinia mississippiensis	**ORDER** **ACCIPITRIFORMES**	**FAMILY** **ACCIPITRIDAE / HAWKS, EAGLES & KITES**

Cool **FACT**

Mississippi Kites may locate their nest next to (or even build around) a wasp nest, which probably helps protect the chicks against climbing predators. Smaller bird species—such as Northern Mockingbirds (page 260), Blue Jays (page 204), and House Sparrows—may nest near or on kite nests, usually coexisting peacefully with the kites.

NORTHERN HARRIER

The Northern Harrier is distinctive even from a long distance: a slim, long-tailed hawk that sports a white patch at the base of its tail, gliding low over a marsh or grassland, its wings held in a V shape. Each gray and white male may mate with several females—sometimes up to five at once—which are larger and brown. These unusual raptors are broadly distributed across North America.

Northern Harriers are the most owl-like of hawks (though they're not related to owls), relying on hearing as well as vision to capture prey. The disk-shaped face looks and functions much like an owl's, its stiff facial feathers helping to direct sound to the ears. This helps it hear mice and voles moving beneath vegetation.

Circus hudsonius	**ORDER** ACCIPITRIFORMES	**FAMILY** ACCIPITRIDAE / HAWKS, EAGLES & KITES

Cool FACT

Juvenile males have pale, greenish yellow eyes, while juvenile females have dark, chocolate brown eyes. The eye color of both sexes changes gradually to lemon yellow by the time they reach adulthood.

COOPER'S HAWK

Among the bird world's most skillful fliers, Cooper's Hawks tear through cluttered tree canopies in high-speed pursuit of other birds. You're most likely to see this common woodland hawk prowling above a forest edge or field, using just a few stiff wingbeats followed by a glide. A smaller look-alike, the Sharp-shinned Hawk, makes identifying the Cooper's Hawk famously tricky. Both species may show up as unwanted guests at bird feeders, looking for an easy meal (but not one of sunflower seeds).

The breeding season is a busy time for male Cooper's Hawks. As with most hawks, males are significantly smaller than their mates, and female Cooper's Hawks specialize in eating medium-size birds. Males tend to be submissive to females, listening for the reassuring call notes the females make when they're willing to be approached. Once mated, the male builds the nest, then provides nearly all the food to the female and young during the ninety days before the young fledge.

Accipiter cooperii	ORDER ACCIPITRIFORMES	FAMILY ACCIPITRIDAE / HAWKS, EAGLES & KITES

Cool FACT

Dodging tree limbs to catch birds is a dangerous lifestyle. In a study of more than three hundred Cooper's Hawk skeletons, 23 percent showed old, healed-over fractures in the bones of the chest, especially of the furcula, or wishbone.

BALD EAGLE

The Bald Eagle has been the national emblem of the United States since 1782 and a spiritual symbol for American Indians for much longer. These regal birds aren't really bald, but their white-feathered heads stand out in contrast to their chocolate brown body and wings. Look for them soaring in solitude—most often in proximity to water—chasing other birds to steal food, or gathering by the hundreds in winter. Once endangered by shooting and pesticides, Bald Eagles have flourished under protection and can be found over much of North America.

Had Benjamin Franklin prevailed, the emblem of the United States might have been the Wild Turkey. Writing in 1784, Franklin disparaged our national bird's thieving tendencies and its vulnerability to harassment by small birds. "For my own part," he wrote, "I wish the Bald Eagle had not been chosen the Representative of our Country. He is a Bird of bad moral Character. He does not get his Living honestly. . . . Besides he is a rank Coward: The little King Bird not bigger than a Sparrow attacks him boldly and drives him out of the District."

Haliaeetus leucocephalus	ORDER ACCIPITRIFORMES	FAMILY ACCIPITRIDAE / HAWKS, EAGLES & KITES

Cool FACT

Sometimes even the national bird has to cut loose. Bald Eagles have been known to play with plastic bottles and other objects pressed into service as toys. One observer witnessed six Bald Eagles passing sticks to each other in midair.

RED-SHOULDERED HAWK

Whether wheeling over a swamp forest or whistling plaintively from a riverine park, a Red-shouldered Hawk is typically a sign of tall woods and water. It's one of our most distinctively marked common hawks, with barred reddish peach underparts and a strongly banded tail. When the bird is in flight, translucent crescents near the wingtips help to identify it at a distance. These forest hawks hunt prey ranging from mice to frogs and snakes—chiefly in eastern forests, though California has a population.

Although American Crows often mob a Red-shouldered Hawk, the relationship is not always one-sided. The two species may chase and try to steal food from each other. Both may attack a Great Horned Owl or join forces to chase the owl out of the hawk's territory.

Buteo lineatus	ORDER ACCIPITRIFORMES	FAMILY ACCIPITRIDAE / HAWKS, EAGLES & KITES

Cool FACT

Red-shouldered Hawks return to
the same nesting territory year after year.
One individual occupied a territory
in Southern California for sixteen
consecutive years.

BROAD-WINGED HAWK

One of the greatest spectacles of migration is a swirling flock of Broad-winged Hawks, evoking a vast cauldron being stirred with an invisible spoon. Each fall, hundreds of thousands of Broad-winged Hawks leave the northern forests for South America. They fill the sky in flocks—also known as "kettles"—that can contain thousands of birds at a time. Such kettles are a prime attraction at many hawk-watching sites. As they move from the broad expanses of North America to the narrow geography of Central America, their numbers get concentrated, leading people to describe a place such as Panama or the Mexican state of Veracruz as a "river of raptors."

A small, stocky raptor with black-and-white bands on the tail, the Broad-winged Hawk is a bird of the forest interior and can be hard to see during the nesting season. Its call is a piercing, two-part whistle.

Buteo platypterus	**ORDER** **ACCIPITRIFORMES**	**FAMILY** **ACCIPITRIDAE / HAWKS,** **EAGLES & KITES**

Cool FACT

Late Pleistocene fossils of Broad-winged Hawks, up to four hundred thousand years old, have been unearthed in Florida, Iowa, Illinois, Virginia, and Puerto Rico.

SWAINSON'S HAWK

A classic species of the wide-open Great Plains and the West, the Swainson's Hawk soars on narrow wings or perches on fence posts and irrigation spouts. These elegant gray, white, and brown hawks hunt rodents from the air, their wings held in a shallow V, or even run after insects on the ground. In the fall, they take off for Argentine wintering grounds in one of the longest migrations of any American raptor—forming flocks of hundreds or thousands as they travel.

The Swainson's Hawk initially suffered from a case of mistaken identity, when a specimen collected in Canada in 1827 and illustrated by William Swainson was confused with the Common Buzzard (*Buteo buteo*) of Europe. The error was corrected in 1832, when the French biologist Charles Lucien Bonaparte (a nephew of Emperor Napoleon I), while working in Philadelphia, recognized the hawk as a new species and named it after the original illustrator—though he based his own description on a drawing by the pioneering naturalist and bird artist John James Audubon.

Buteo swainsoni	**ORDER** ACCIPITRIFORMES	**FAMILY** ACCIPITRIDAE / HAWKS, EAGLES & KITES

Cool FACT

Swainson's Hawks feed their chicks the usual three R's of the North American buteo diet: rodents, rabbits, and reptiles. But when they're not breeding, the adults switch to a diet made up almost exclusively of insects (especially grasshoppers and dragonflies).

RED-TAILED HAWK

This is probably the most common hawk in North America. If you've got sharp eyes, you'll see several individuals on almost any long car ride, anywhere. Red-tailed Hawks soar above open fields, turning slow circles on their broad, rounded wings. At other times you'll see them atop telephone poles, eyes fixed on the ground to catch the movements of a vole or a rabbit, or simply waiting out cold weather before climbing a thermal updraft into the sky.

Bird bodies are amazingly adapted for life in the air. The Red-tailed Hawk is one of the largest birds you'll see in North America, yet even the biggest females weigh in at only about three pounds. A similar-size small dog might weigh ten times that.

Buteo jamaicensis	**ORDER** **ACCIPITRIFORMES**	**FAMILY** **ACCIPITRIDAE / HAWKS, EAGLES & KITES**

Cool **FACT**

The Red-tailed Hawk has a thrilling, raspy scream that sounds exactly like a raptor should sound. At least, that's what Hollywood directors seem to think. Whenever a hawk or eagle appears onscreen, no matter what species, the shrill cry on the soundtrack is almost always a Red-tailed Hawk.

FERRUGINOUS HAWK

Found in prairies, deserts, and open range of the West, the regal Ferruginous Hawk hunts from a lone tree or rock outcrop, or from high in the sky. This largest of North American hawks lives up to its species name, *regalis*—stunningly pale, it has a streaked gray head, rusty (ferruginous) shoulders and legs, and gleaming white underparts. A rarer dark morph is reddish chocolate overall. Ferruginous Hawks eat a diet of small mammals, sometimes standing in wait above prairie dog or ground squirrel burrows for prey to emerge.

They threaten each other by hopping and flapping their wings, creating a feeding frenzy that may attract more of their kind, along with Golden and Bald Eagles.

Buteo regalis	**ORDER** ACCIPITRIFORMES	**FAMILY** ACCIPITRIDAE / HAWKS, EAGLES & KITES

Cool FACT

When bison still roamed the West, Ferruginous Hawk nests contained bison bones and hair along with sticks and twigs.

KING RAIL

A secretive dweller of freshwater and brackish marshes, mainly in the Southeast, the King Rail is richly colored in shades of chestnut, buff, and brown with crisp black and white stripes on its flanks. This largest of North America's rails slips through short marsh vegetation in search of crayfish, crabs, and frogs. Its call is a steady series of harsh notes, deeper and more resonant than that of the very similar Clapper Rail. Owing to wetland loss and modification, King Rail numbers have declined an alarming 90 percent in the last half century, putting the species on the Yellow Watch List (a roster of species whose declines are closely watched, compiled by a consortium of organizations concerned with bird conservation).

The King Rail usually gets its food in aquatic habitats but occasionally catches food on land. In that case, the rail often carries the prey to water and dunks it before eating it.

Rallus elegans	**ORDER** **GRUIFORMES**	**FAMILY** **RALLIDAE / RAILS, GALLINULES & COOTS**

The adult King Rail molts completely after nesting and is flightless for nearly a month while it grows a new set of feathers.

PURPLE GALLINULE

In the marshes of the extreme southeastern United States lives one of the most vividly colored birds on the continent. The plumage of Purple Gallinules combines cherry red, sky blue, moss green, aquamarine, indigo, violet, and school-bus yellow—a color palette that blends surprisingly well with tropical and subtropical wetlands. Watch for these long-legged, long-toed birds stepping gingerly across water lilies and other floating vegetation as they hunt frogs and invertebrates or pick at tubers.

Purple Gallinules are remarkable fliers, turning up far outside their normal range surprisingly often. They've been spotted in Iceland, Switzerland, South Georgia Island (near Antarctica), the Galápagos Islands, and South Africa. These locations may not be accidental: a study noted that years of severe drought in the gallinule's core range tended to produce more so-called vagrants in autumn and winter. In other words, the wanderers may not be lost but instead seeking places where food is more abundant than in their usual haunts.

Porphyrio martinica

ORDER

GRUIFORMES

FAMILY

RALLIDAE / RAILS, GALLINULES & COOTS

In tropical areas, such as Panama and Costa Rica, Purple Gallinules often have multiple broods per year. The juvenile and immature birds from earlier nestings often help the parents feed and protect the new chicks and defend the family's territory—an unusual behavior for rails.

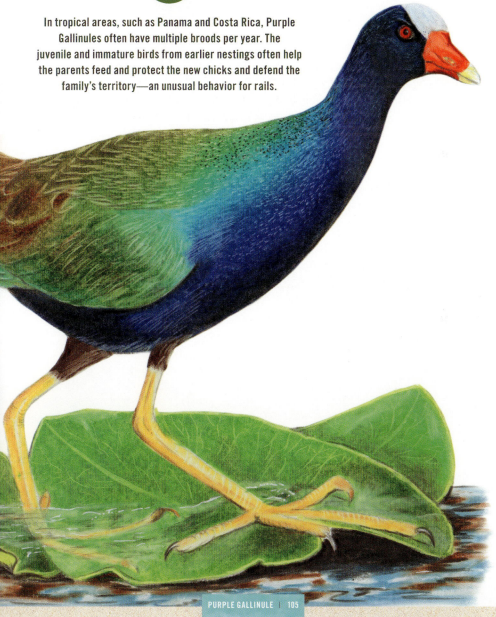

AMERICAN COOT

The aquatic American Coot reminds us that not everything that floats is a duck. A close look at a coot—that small head, those scrawny legs—reveals a different kind of bird entirely. The dark bodies and stubby white bills of American Coots are commonly seen in nearly any open water across the continent, and they often mix with ducks. But they're closer relatives of the gangly Sandhill Crane (page 108) and the shy rails than of Mallards or teal.

Although it swims like a duck, the American Coot does not have a duck's webbed feet. Instead, each of the coot's long toes has broad lobes of skin that help it kick through the water. As the coot paddles with the foot, the flange-like lobes flare outward, displacing lots of water with the backward stroke. But as the foot moves forward again in the water, the lobes fold inward, reducing the "drag" against the water and making their effort more energy efficient. The lobes also help distribute the bird's weight on mucky ground.

Fulica americana

ORDER

GRUIFORMES

FAMILY

RALLIDAE / RAILS, GALLINULES & COOTS

Cool
FACT

The ecological impact of common animals, like this ubiquitous waterbird, can be impressive when added up. One estimate, from a wintering site on the coast of Virginia where coots were once common, suggested that the local coot population ate 216 tons (in dry weight) of vegetation each winter.

SANDHILL CRANE

Whether it's a lone bird pacing across a wet meadow or a flock of thousands filling the sky, the stately Sandhill Crane compels attention. These tall, gray-bodied, crimson-capped wading birds breed in open wetlands, fields, and prairies across North America. They congregate in great numbers, filling the air with their distinctive cries. Mates display to each other with exuberant dances. Sandhill Crane populations are generally strong, but isolated populations in Mississippi and Cuba are endangered. Cranes are important to human cultures worldwide, figuring prominently in Japanese art, for example. The memorable calls and elaborate dances of Sandhill Cranes have been depicted in the visual arts and dance of American Indians. Crane festivals, usually held when the birds congregate in large flocks during migration, demonstrate ongoing contemporary interest in Sandhill Cranes.

The crane's call is a loud, rolling, trumpeting sound, whose unique tone is a product of anatomy: Sandhill Cranes have long tracheas (windpipes) that coil into the sternum. This helps the sound develop a lower pitch and resonant harmonics.

Antigone canadensis	**ORDER** **GRUIFORMES**	**FAMILY** **GRUIDAE / CRANES**

Cool FACT

Sandhill Cranes are known for their dancing skills. Courting cranes stretch their wings, pump their heads, bow, and leap into the air in a graceful and energetic performance.

WHOOPING CRANE

The Whooping Crane is the tallest bird in North America and one of the most awe-inspiring, with its snowy white plumage, crimson cap, bugling call, and graceful courtship dance. It is also among our rarest birds, its survival a testament to the tenacity and creativity of conservation biologists. The species declined to around twenty birds in the 1940s, but—through captive breeding, wetland management, and an innovative program that teaches young cranes how to migrate—its numbers have risen to about six hundred today.

Hefty for a bird at fifteen pounds, an adult Whooping Crane has a wingspan of more than seven feet and is as tall as many humans, reaching around five feet. Also five feet long is its trachea, which coils into its sternum, equipping the bird to produce a loud call that carries long distances over marshland. The name Whooping Crane probably comes from either its single-note guard call or its courtship duet.

Grus americana

ORDER

GRUIFORMES

FAMILY

GRUIDAE / CRANES

Cool FACT

The only self-sustaining population of Whooping Cranes is a naturally occurring flock that breeds in Canada and winters in Texas. Three reintroduced populations exist with the help of captive breeding programs. One of these is migratory: researchers use ultralight aircraft to teach young cranes to migrate between Wisconsin breeding grounds and Florida wintering grounds.

BLACK-NECKED STILT

Black-necked Stilts are among the stateliest of the shorebirds—their long, rose pink legs, long thin black bill, and striking black-and-white plumage make them unmistakable at a glance. They move deliberately when foraging, walking slowly through wetlands in search of tiny aquatic prey. When disturbed, stilts are vociferous, to put it mildly; their high, yapping calls carry for some distance.

In the Hawaiian subspecies of Black-necked Stilt (*H. m. knudseni*), the black on its neck extends much farther forward than in the mainland forms. *Knudseni* lives mainly in the few freshwater wetlands found on the islands; its numbers have sharply declined due to habitat loss and hunting. In the Hawaiian language it is called *Ae'o*, which means "one standing tall."

Himantopus mexicanus	**ORDER** CHARADRIIFORMES	**FAMILY** RECURVIROSTRIDAE / STILTS & AVOCETS

Cool **FACT**

Black-necked Stilts sometimes participate in a "popcorn display," in which a group of birds gather around a ground predator and jump, hop, or flap their wings to drive it away from stilt nests.

AMERICAN AVOCET

The American Avocet takes avian elegance to a new level. This long-legged wader glides through shallow waters, swishing its slender, upturned (or "recurved," hence the genus name) bill from side to side to catch aquatic invertebrates. Avocets forage along coastal waters, often standing on one leg when resting. The bird dons a sophisticated look for summer—all black and white except for a rusty head and neck, which turn grayish white in the winter.

In what's known as *brood parasitism*, a female American Avocet may lay eggs in the nest of another female, who incubates them without noticing. The nests of other species also may be targets; American Avocet eggs have been found in the nests of Mew Gulls, for example. Conversely, species such as Common Terns and Black-necked Stilts (page 112) may parasitize avocet nests. When stilts were observed to do this, the avocets reared the hatchlings as if they were their own.

Recurvirostra americana	**ORDER** CHARADRIIFORMES	**FAMILY** RECURVIROSTRIDAE / STILTS & AVOCETS

Cool FACT

In response to a perceived predator threat, the American Avocet gives a series of call notes that gradually rise in pitch, simulating the Doppler effect: that is, making the sound's approach seem faster than it actually is.

Cool FACT

American Oystercatchers are the only birds in their environment capable of opening large mollusks, such as clams and oysters (though large gulls drop clams onto rocks or pavement to shatter their thick shells). Foraging oystercatchers often attract other birds—including Willets (page 124), gulls, and Ruddy Turnstones—eager to share (or steal from) the oystercatcher's "raw bar."

AMERICAN OYSTERCATCHER

A boldly patterned shorebird with yellow eyes and a vivid red-orange bill, the American Oystercatcher survives almost exclusively on shellfish—clams, oysters, and other saltwater mollusks. Because of this specialized diet, oystercatchers live only in a narrow ecological zone of saltmarshes and barrier beaches. Look for American Oystercatchers on barrier islands and oyster beds, where these high-contrast birds can be identified from a long way off—unlike their frequent companions, the various sandpipers and plovers. Along much of the Pacific Coast, the species is replaced by the similar but all dark Black Oystercatcher.

American Oystercatchers are currently numerous but sensitive to development and traffic on the beaches where they nest; the species is on the Yellow Watch List.

Haematopus palliatus	ORDER CHARADRIIFORMES	FAMILY HAEMATOPODIDAE / OYSTERCATCHERS

KILLDEER

A shorebird you can see without going to the beach, Killdeer are graceful plovers common on lawns, golf courses, athletic fields, and parking lots. These tawny birds, banded in white and black around the head and neck, run across the ground in spurts, stopping abruptly every so often to check their progress or see if they've startled up any insect prey. Their call, a far-carrying, excited *kill-deer*, is often given in flight as the bird circles overhead on slender wings and may be heard even after dark.

Gravel rooftops attract Killdeer for nesting, but they can be dangerous places to raise a brood. High parapets and screened drain openings can prevent chicks from venturing forth. The adults eventually lure chicks off the roof, which itself can be dangerous—although one set of chicks survived a leap from a seven-story building.

Charadrius vociferus	**ORDER** **CHARADRIIFORMES**	**FAMILY** **CHARADRIIDAE / PLOVERS & LAPWINGS**

Cool FACT

A well-known denizen of dry habitats, the Killdeer is actually a proficient swimmer. Adults swim well in swift-flowing water, and chicks can swim across small streams.

WILSON'S SNIPE

Although a long tradition of "snipe hunt" pranks at summer camp has convinced many people otherwise, the Wilson's Snipe is not a made-up creature. These plump, long-billed sandpipers are among the most widespread shorebirds in North America. Their secretive natures and brown and buff coloration can make them tough to see. But in summer you may spot one standing on a fence post or taking to the sky with a fast, zigzagging flight, or hear the unusual "winnowing" sound made by its tail.

The stocky profile of the Wilson's Snipe is thanks in part to extra-large pectoral (breast) muscles, which account for nearly a quarter of the bird's weight—the highest percent among all shorebirds. Thanks to these massive flight muscles, the chunky snipe can reach speeds estimated at 60 miles an hour.

Gallinago delicata	**ORDER** CHARADRIIFORMES	**FAMILY** SCOLOPACIDAE / SANDPIPERS & ALLIES

Cool FACT

The word *sniper* originated in the 1770s among British soldiers in India who hunted snipe as game. The birds are still hunted in many countries, including the United States, though their fast, erratic flight style makes them difficult targets.

AMERICAN WOODCOCK

Superbly camouflaged against the leaf litter, the mottled brown American Woodcock ambles slowly along the forest floor, probing the soil with its long bill in search of earthworms.

Unlike its coastal relatives, this plump little shorebird lives in young forests and shrubby old fields across eastern North America. Its low-key plumage and low-profile behavior make it hard to find except in the springtime at dawn or dusk, when the males show off for females by uttering loud, nasal *peent!* calls and performing dazzling aerial displays. This last behavior—what the natural history writer Robert Finch calls "the spiraling, upward flight of the star-dancing woodcock"—is a memorable sight. The conservationist Aldo Leopold declared that the bird's "sky dances" are a living "refutation of the theory that the utility of a game bird is to serve as a target, or to pose gracefully on a slice of toast."

Scolopax minor	ORDER CHARADRIIFORMES	FAMILY SCOLOPACIDAE / SANDPIPERS & ALLIES

Wouldn't it be useful to have eyes in the back of your head? American Woodcocks come close—their large eyes are positioned high and near the back of their skull. This arrangement lets them keep watch for danger from above while their heads are down, exploring the soil for food.

SPOTTED SANDPIPER

The dapper Spotted Sandpiper makes a great ambassador for the notoriously difficult-to-identify shorebirds. This handsome little bird is distinctive in both looks and actions—richly spotted breeding plumage, a teetering gait, and stuttering wingbeats—and it occurs all across North America. Spotted Sandpipers also have intriguing social lives, in which females take the lead with showy courtship dances, and males raise the young. All in all, this is among our most memorable shorebirds.

The species' typical teetering motion has given rise to nicknames like teeter-peep, teeter-bob, and jerk or perk bird, yet its function has not been determined. Chicks teeter nearly as soon as they hatch from the egg. Spotted Sandpipers, like Solitary Sandpipers, waterthrushes, and many other birds that live near water, make the teetering movements regularly, including during aggressive interactions and courtship.

Actitis macularius	**ORDER** **CHARADRIIFORMES**	**FAMILY** **SCOLOPACIDAE /** **SANDPIPERS & ALLIES**

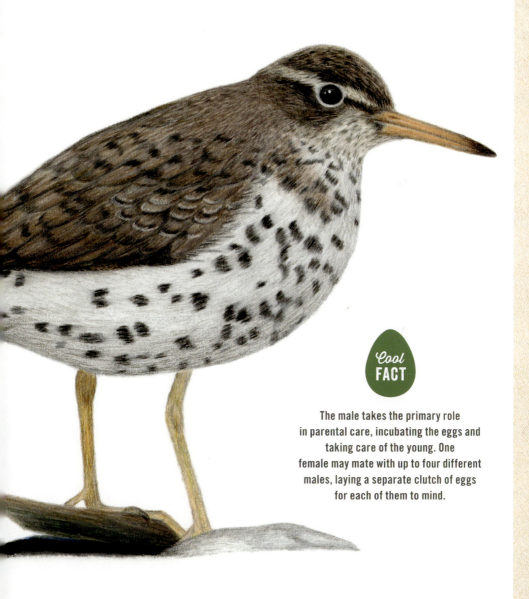

The male takes the primary role
in parental care, incubating the eggs and
taking care of the young. One
female may mate with up to four different
males, laying a separate clutch of eggs
for each of them to mind.

WILLET

A piercing call and distinctive wing markings make the Willet one of our most conspicuous large shorebirds. Whether in mottled brown breeding plumage or gray winter colors, Willets in flight reveal a bold white and black stripe running the length of each wing. These long-legged, straight-billed shorebirds feed along beaches, mudflats, and rocky shores. Willets are common on most of our coastlines—learning to recognize them is a useful stepping-stone to identifying other shorebirds.

Willets and their fellow shorebirds were once popular for food. In his famous *Birds of America* accounts, John James Audubon wrote that Willet eggs were tasty and the young "grow rapidly, become fat and juicy, and by the time they are able to fly, afford excellent food." By the early 1900s, Willets had almost vanished north of Virginia. The Migratory Bird Treaty Act of 1918 banned market hunting and marked the start of the Willet's comeback.

Tringa semipalmata	ORDER CHARADRIIFORMES	FAMILY SCOLOPACIDAE / SANDPIPERS & ALLIES

Cool
FACT

Like Killdeer, Willets will pretend to
be disabled by a broken wing in
order to draw attention to themselves
and lure predators away from
their eggs or chicks.

ATLANTIC PUFFIN

A sharply dressed black-and-white seabird with a huge, multicolored bill, the Atlantic Puffin is often called the clown of the sea. It breeds in burrows on islands in the North Atlantic and winters at sea. In flight, puffins flap their small wings frantically to stay aloft—but underwater those wings become powerful flippers that allow the birds to catch small fish one by one until their beak is full.

Once widely hunted, this long-lived bird is reestablishing its small range in the United States, though warming ocean waters are causing breeding failures in other parts of the North Atlantic.

Fratercula arctica	ORDER **CHARADRIIFORMES**	FAMILY **ALCIDAE / AUKS, MURRES & PUFFINS**

Cool **FACT**

A lighthouse keeper on Iceland's Westman Islands
has been banding puffin chicks for more than sixty years.
The islands are home to the world's largest puffin
colony, and the keeper, Oskar Sigurdsson, earned a spot in the
Guinness World Records for his prolific banding:
more than ninety thousand birds over those six decades,
including more than fifty-five thousand puffins.

FRANKLIN'S GULL

"Seabird" is something of a misnomer for this delicate-looking gull, which is rarely seen on North American coastlines, though it nests by the thousands in the interior marshes, especially in wildlife refuges. The Franklin's Gull does spend winters along the coasts of Chile and Peru. Its buoyant, swift, graceful flight helps it to catch flying insects and small fish, as well as to make its long migrations. Breeding adults have black heads and pink-tinged underparts, giving rise to the folk name "rosy dove." Franklin's Gulls are gregarious throughout the year; on their wintering grounds, more than a million have been reported in a single day.

In breeding plumage—sometimes in nonbreeding plumage as well—the Franklin's Gull often shows a rosy pink cast on its chest and abdomen. The color fades as the breeding season progresses and sunlight breaks down the pigment.

Leucophaeus pipixcan	**ORDER** **CHARADRIIFORMES**	**FAMILY** **LARIDAE / GULLS, TERNS & SKIMMERS**

Cool FACT

Like many long-distance migrants, Franklin's Gulls have strayed far from their normal range. Vagrants (birds observed far from home) have turned up in Taiwan, Hong Kong, Australia, and New Zealand.

RING-BILLED GULL

Familiar aerial acrobats, Ring-billed Gulls nimbly pluck tossed tidbits from the air. Comfortable around humans, they frequent parking lots, garbage dumps, beaches, and fields, sometimes by the hundreds. These are the gulls you're most likely to see far away from coastal areas—in fact, most Ring-billed Gulls nest in the interior of the continent, near fresh water. A black band (the "ring") encircling its yellow bill helps distinguish adult Ring-bills from other gulls—but look closely, as some species have black or red spots on the bill.

Ring-billed Gulls near Tampa Bay, Florida, became accustomed to feasting on garbage at an open landfill site. When operators replaced the dumping grounds with closed incinerators, the thwarted scavengers found another open dump. But the pattern continues across the gull's range: when waste-management practices shift from open landfills to closed incinerators, gull numbers often drop.

Larus delawarensis	**ORDER** **CHARADRIIFORMES**	**FAMILY** **LARIDAE / GULLS, TERNS & SKIMMERS**

Cool FACT

Ring-billed Gull nesting colonies normally include a small percentage of female pairs. Fertilized by an obliging male, each female mate lays a clutch of eggs, leading to "superclutches" of five to eight eggs in a nest.

BLACK TERN

An outlier in a world of white seabirds, breeding Black Terns are a handsome mix of charcoal gray and jet black. Their streamlined form and neatly pointed wings provide tremendous agility as these birds flutter and swoop to pluck fish from the water's surface or veer to catch flying insects, much as a swallow does. Black Terns nest in large freshwater marshes, in small, loose colonies, and winter in flocks along tropical coastlines. In the last half century, this species has lost about half its North American population, likely due to loss of wetlands in breeding and migration zones along with overfishing and pesticide use cutting into its food supply.

The Black Tern and two Old World species, the White-winged Tern and Whiskered Tern, are known as "marsh terns" for their habit of breeding in freshwater marshes. All three belong to the genus *Chlidonias*. Stray White-winged Terns have occasionally spent the summer in North America and nested with Black Terns, in at least one case producing hybrid offspring.

Chlidonias niger	**ORDER** **CHARADRIIFORMES**	**FAMILY** **LARIDAE / GULLS, TERNS & SKIMMERS**

Cool FACT

The Black Tern is very social. It breeds in loose colonies and usually forages, roosts, and migrates in flocks of a few to more than a hundred birds— occasionally up to several thousand.

FORSTER'S TERN

Flashing silvery wings and an elegantly forked tail, Forster's Terns cruise above the shallow waters of marshes and coastlines, looking for fish. These medium-sized white terns are often confused with the similar Common Tern, but Forster's Terns have a longer tail and, in nonbreeding plumage, a distinctive black eye patch. Further, where Common Terns breed on outer beaches and barrier islands, the Forster's nests farther inland, on edges of freshwater marshes and saltmarshes.

Forster's Terns are the only medium-sized terns found in the United States mainland during winter, most common and widespread then along ocean coasts and in the inland Southeast. Look for them especially around shorelines, bays, and marshes; at this time of year, their thick black eye patch makes them stand out.

Sterna forsteri
ORDER **CHARADRIIFORMES**
FAMILY **LARIDAE / GULLS, TERNS & SKIMMERS**

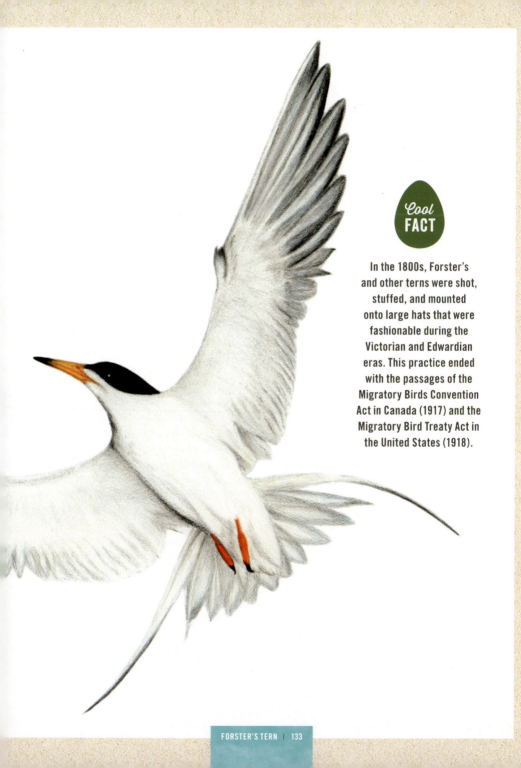

In the 1800s, Forster's and other terns were shot, stuffed, and mounted onto large hats that were fashionable during the Victorian and Edwardian eras. This practice ended with the passages of the Migratory Birds Convention Act in Canada (1917) and the Migratory Bird Treaty Act in the United States (1918).

BLACK SKIMMER

A long-winged bird with stark black-and-white plumage, the Black Skimmer forages gracefully in flight. The skimmer feeds by opening its uneven bill and dropping the long, narrow lower mandible into the water, skimming along until it feels a fish. Then the bird's neck relaxes, its jaw closes quickly, and it whips the fish out of the water. The world's three species of skimmer are the only birds that feed in this manner. Because they feed essentially by touch, they can even forage at night. The startling beak shape takes time to develop: at hatching, the young skimmer's mandibles are of equal length, but after four weeks, the lower mandible is nearly a half inch longer than the upper.

Possibly the best description of the Black Skimmer's bounding, head-down foraging style came from the great seabird biologist Robert Cushman Murphy in 1936. He said they look like "unworldly . . . aerial beagles hot on the scent of aerial rabbits."

Cool FACT

The Black Skimmer has many folk names: it has been called scissor-bill, shearwater, seadog, flood gull, storm gull, razorbill, and cutwater.

Rynchops niger

ORDER
CHARADRIIFORMES

FAMILY
LARIDAE / GULLS, TERNS & SKIMMERS

INCA DOVE

Swathed in warm gray, scaly-looking feathers, the tiny Inca Dove blends right in with its suburban desert habitats. That is, until it bursts into flight, making a dry, rattling whir with its wings while flashing chestnut underwings and white in its tail. It nods its head forward and back with each step and coos a mournful *No hope* from the trees. In recent years, this dove has expanded northward and is now seen as far north as Colorado, perhaps due to increased human settlement.

Some birds can tolerate seriously cold temperatures, but not the Inca Dove. When the temperature drops to around twenty degrees F, these southern doves get cold and take action, huddling together in the sunshine to stay warm. Sometimes they even sit on top of each other, forming a dove pyramid up to three doves high—a behavior called "pyramid roosting."

Columbina inca	ORDER **COLUMBIFORMES**	FAMILY **COLUMBIDAE / PIGEONS & DOVES**

Cool **FACT**

The eyes of an Inca Dove may give away what it is feeling. Inca Doves have red eyes, but the eyes become even brighter when an intruder threatens.

MOURNING DOVE

This graceful, slender-tailed, small-headed dove is common across the continent. In fact, it's among the most widespread terrestrial birds in this hemisphere, found in all the lower forty-eight states, southern Canada, and temperate Mexico. This habitat generalist has benefited from human changes to the landscape. Mourning Doves perch on telephone wires and forage for seeds on the ground, especially under feeders. Their flight is fast and bullet straight; their soft, drawn-out calls sound like laments. When taking off, their wings make a sharp whistling or whinnying.

The Mourning Dove is also the most frequently hunted game bird in North America. Every year hunters harvest more than twenty million, but this dove remains one of our most abundant birds, with a United States population estimated at 350 million.

Zenaida macroura	ORDER **COLUMBIFORMES**	FAMILY **COLUMBIDAE / PIGEONS & DOVES**

Cool FACT

Mourning Doves eat roughly 12 to 20 percent of their body weight per day, or seventy-one calories on average.

For a generation of Americans, the familiar *beep-beep!* of the Warner Brothers cartoon character Road Runner was part of the Saturday morning soundtrack. Despite the character's perennial triumphs over Wile E. Coyote, real-life coyotes pose a real danger. They can reach a top speed of forty-three miles an hour—more than twice as fast as roadrunners.

GREATER ROADRUNNER

Born to run, the Greater Roadrunner can outrace a human, kill a rattlesnake, and thrive in the harsh landscapes of the desert Southwest. Roadrunners can reach two feet from sturdy bill to white tail tip. They sport a bushy, blue-black crest, and their mottled plumage blends well with dusty shrubs. As it runs, the bird holds its lean frame nearly parallel to the ground and uses its long tail as a rudder. The species' range has recently extended eastward into Missouri and Louisiana.

Greater Roadrunners are monogamous, maintain a long-term pair bond, and mutually defend a large, multipurpose territory. Paisano, chaparral cock, snake killer, and medicine bird are a few of the colorful names bestowed on this conspicuous cuckoo of the American Southwest.

Geococcyx californianus	**ORDER** CUCULIFORMES	**FAMILY** CUCULIDAE / CUCKOOS

YELLOW-BILLED CUCKOO

Yellow-billed Cuckoos are slender, long-tailed birds that manage to stay well hidden in deciduous woodlands. They usually sit stock still as they hunt for large caterpillars. From the bird's shaded perch, bold white spots on the underside of its tail may be the most visible feature. Fortunately, its drawn-out, knocking call is very distinctive. Yellow-billed Cuckoos are fairly common in the East but have become rare in the West in the last half century.

Female Yellow-billed Cuckoos don't lay eggs all at once: the period from one egg to the next can stretch as long as five days. This *asynchronous* egg laying means that the oldest chick can be close to leaving the nest when the youngest is just hatching. When food is in short supply, the male may remove the youngest bird from the nest, though (unlike the related Greater Roadrunner, page 140) it doesn't feed the chick to the older siblings.

Coccyzus americanus	ORDER CUCULIFORMES	FAMILY CUCULIDAE / CUCKOOS

Cool FACT

Yellow-billed Cuckoos are among the few bird species able to eat hairy caterpillars. In the East they eat large numbers of tent caterpillars— as many as a hundred in one sitting.

BARN OWL

Ghostly pale and normally strictly nocturnal, Barn Owls are silent predators of the night world. Lanky, with a whitish face, chest, and belly, and buff-colored on top, these owls roost in hidden, quiet places during the day. By night, they hunt on buoyant wingbeats in open fields and meadows. You can locate them by listening for their eerie, raspy calls, quite unlike the hoots of other owls but very similar to the begging calls of juvenile Barred and Great Horned Owls. Barn Owls nest in a wide variety of cavities, natural and those made by humans: trees, cliffs, caves, riverbanks, church steeples, haylofts in barns, and nest boxes. Despite being distributed worldwide, they are declining in parts of their range due to habitat loss.

Up to forty-six different races of the Barn Owl have been described worldwide. The North American form is the largest, weighing more than twice as much as the smallest race from the Galápagos Islands.

Tyto alba	ORDER STRIGIFORMES	FAMILY TYTONIDAE / BARN OWLS

Cool FACT

Barn Owls swallow their prey whole—skin, bones, and all. Instead of passing all that material through their digestive tracts, they cough up pellets about twice a day. The pellets make a great record of what the owls have eaten, and scientists study them to learn more about the owls and the ecosystems they live in.

EASTERN SCREECH-OWL

If a mysterious, descending trill catches your attention after dark, bear in mind the spooky sound may come from an owl no bigger than a pint glass. Common east of the Rockies in woods, suburbs, and parks, the Eastern Screech-Owl is found wherever trees are, and they're very willing to nest in backyard nest boxes. These supremely camouflaged birds hide out in nooks and tree crannies through the day, so train your ears to listen for them at night.

Smaller birds can help you find screech-owls during the day. Listen for a commotion of Blue Jays (page 204), chickadees, and Tufted Titmouse (page 231)—they may be mobbing a screech-owl or other raptor, swooping around it while making noisy calls. This can be enough of a nuisance to make the owl move on; it also alerts other birds to the predator's presence and teaches younger members of a flock about the danger.

Megascops asio	ORDER STRIGIFORMES	FAMILY STRIGIDAE / OWLS

GREAT HORNED OWL

With its long ear tufts, intimidating yellow-eyed stare, and deep hooting voice, the Great Horned Owl is the quintessential owl of storybooks. This powerful, long-lived predator can take down birds and mammals even larger than itself, but it also dines on daintier fare such as scorpions, mice, and frogs. It's among the most common owls in North America, equally at home in deserts, wetlands, forests, grasslands, backyards, cities, and almost any other semi-open habitat between the Arctic and the tropics.

Great Horned Owls have large eyes with pupils that open wide in low light and retinas containing many rod cells for excellent night vision. The eyes don't move in their sockets, but the owl can swivel its head more than 180 degrees to look in any direction. Its hearing is highly sensitive, thanks in part to facial disc feathers that direct sound waves to the ears.

Bubo virginianus	**ORDER** STRIGIFORMES	**FAMILY** STRIGIDAE / OWLS

Cool FACT

When clenched, a Great Horned Owl's strong talons require a force of twenty-eight pounds to open. The owls use this deadly grip to sever the spine of large prey.

BURROWING OWL

The small, sandy-colored Burrowing Owl looks slightly comical, with a chunky frame held erect on long legs and bright yellow eyes with pale, bushy brows. But it's a remarkably versatile bird that is active day and night, hunts on the ground, and lives in underground burrows. The birds either dig these themselves or take them over from a prairie dog, ground squirrel, or desert tortoise. They live in grasslands, deserts, and other open habitats, where they hunt mainly insects and rodents. However, their numbers have declined sharply with human alteration of their habitat and falling numbers of prairie dogs and ground squirrels.

In the absence of suitable homes created by other burrowing animals, Burrowing Owls have been known to nest in piles of PVC pipe and other lairs unintentionally provided by humans. Conservationists take advantage of the owls' adaptability by supplying artificial burrows made of buckets, pipes, tubing, and other human-made materials.

Athene cunicularia	ORDER STRIGIFORMES	FAMILY STRIGIDAE / OWLS

Cool FACT

Burrowing Owls often stash extra food to ensure an adequate supply while incubating their eggs and brooding chicks. When food is plentiful, the birds' underground larders can reach prodigious sizes. One cache observed in Saskatchewan in 1997 contained more than two hundred rodents.

SPOTTED OWL

In the 1990s, the Spotted Owl was catapulted into the spotlight during logging debates in the Pacific Northwest. This large, brown-eyed owl lives in mature forests of the West, from the giant old growth of British Columbia and Washington to California's oak woodlands and the steep canyons of the Southwest. At night, it silently hunts small mammals such as wood rats and flying squirrels.

Three subspecies are recognized. The Northern Spotted Owl (*S. o. caurina*) lives from Northern California to British Columbia; it is the darkest brown with the smallest white spots. The California Spotted Owl (*S. o. occidentalis*) lives only in California, is lighter brown, and has larger spots. The Mexican Spotted Owl (*S. o. lucida*) is the smallest and lightest race with the largest white spots. It lives from Utah and Colorado southward into southern Mexico.

Strix occidentalis	ORDER STRIGIFORMES	FAMILY STRIGIDAE / OWLS

Cool FACT

Young owls often *branch*, or leave the nest to perch on adjacent limbs before they can fly. When young Spotted Owls do fly, their first attempts can be awkward, ending in clumsy landings or with a fluffy owlet hanging upside down until it can regain its perch.

BARRED OWL

The Barred Owl's hooting call, *"Who cooks for you? Who cooks for you-all?"* is a classic sound of old forests and treed swamps. But this attractive owl, with its soulful brown eyes and brown-and-white-striped plumage, can go completely unnoticed as it flies noiselessly through the dense canopy or snoozes on a tree limb. Originally a bird of the East, during the twentieth century it spread through the Pacific Northwest and southward into California.

The Great Horned Owl is the most serious predatory threat to the Barred Owl. Although the two species often live in the same areas, a Barred Owl will move to another part of its territory when a Great Horned Owl is nearby. In turn, the more aggressive Barred Owl has been known to displace and hybridize with the Spotted Owl, a further threat to that already imperiled species.

Strix varia	ORDER **STRIGIFORMES**	FAMILY **STRIGIDAE / OWLS**

Cool **FACT**

Young Barred Owls can climb trees by grasping the bark with their bill and talons, flapping their wings, and walking their way up the trunk.

COMMON NIGHTHAWK

On warm summer evenings, Common Nighthawks roam the skies over treetops, grasslands, and cities. Their sharp, electric *peent!* call is often the first clue to their presence. In the dim half-light, these long-winged birds fly in graceful loops as they chase insects, flashing white patches on the outer part of each wing. These fairly common but declining birds make no nests, usually laying their eggs on the ground. Their young are extremely well camouflaged, and even the adults seem to vanish as soon as they land.

On summer evenings, keep an eye and ear out for the male Common Nighthawk's dramatic "booming" display flight. Flying slightly above the treetops, he abruptly dives earthward. Peeling out of his dive (sometimes just a few meters from the ground), he flexes his wings downward; air rushing across the wingtips makes a deep booming or whooshing sound, as if a race car has just passed by. The dives may be directed at females or at territorial intruders—including people!

Chordeiles minor

ORDER

CAPRIMULGIFORMES

FAMILY

CAPRIMULGIDAE / NIGHTJARS & ALLIES

The name *nighthawk* itself is a bit of a
misnomer, since the bird is neither strictly
nocturnal—it's active at dawn and dusk—
nor closely related to hawks.

CHIMNEY SWIFT

A bird best identified by its silhouette—what some describe as a "cigar with wings" profile—the brownish gray Chimney Swift nimbly maneuvers over rooftops, fields, and rivers to catch insects. Its tiny body, curving wings, and stiff, shallow wingbeats make its flight style as distinctive as its fluid, chattering call. This enigmatic little bird forages only in flight. It cannot perch, so when it must land, it clings to vertical walls inside chimneys or in hollow trees or caves. This species has suffered sharp declines, likely due to changes in prey abundance and unknown threats during migration.

Before European settlement brought chimneys to North America, Chimney Swifts nested in caves, cliff faces, and hollow trees. Their numbers rose as they adopted chimneys for nest sites.

Chaetura pelagica	ORDER CAPRIMULGIFORMES	FAMILY APODIDAE / SWIFTS

Cool **FACT**

Chimney Swifts are among the most aerial of birds, in flight almost constantly except when roosting overnight and nesting. When they do come to rest, they never sit on perches like most birds. Their long claws are suited only for clinging to vertical surfaces.

VAUX'S SWIFT

An aerialist of western forests, the Vaux's Swift is a dark, tiny-bodied, narrow-winged bird much like the Chimney Swift of the eastern United States. It spends most of the day in the air, taking small insects and spiders in rapid, twisting flight. These swifts roost and even nest communally in hollow trees in mature evergreen forests, less often in chimneys. Adults construct a nest of twigs, cemented with their saliva to the inside of a tree cavity, and roost near the nest, clinging vertically to the side of the cavity.

Vaux's Swifts roost communally by the hundreds or sometimes the thousands—presumably to conserve heat. Their body temperature drops and they become torpid on cold nights, reviving in the warmth of day. This species and the unrelated Pygmy Nuthatch (page 238) are the only species in North America that regularly combine these three techniques (sheltering, huddling, and torpor) to survive the cold.

Chaetura vauxi	**ORDER**	**FAMILY**
	CAPRIMULGIFORMES	**APODIDAE / SWIFTS**

Cool **FACT**

To feed their young, adult Vaux's Swifts may make fifty trips to the nest each day, beginning at dawn and ending at dusk. Each parent feeds the nestlings a ball of about 115 insects per visit. That means a single pair of swifts may remove about 11,500 insects from the air daily!

WHITE-THROATED SWIFT

White-throated Swifts are hallmarks of the cliffs and canyon walls of scenic western North America. Living up to their generic name, *Aeronautes* (sky sailor), these striking black-and-white birds seem to defy physics as they dive, twist, and turn at incredible speeds, pursuing insects aloft. Courting birds make spectacular dives toward earth, one clinging to the other's back, separating as they pull out of the plummet just above the ground.

A highly social creature, the White-throated Swift sleeps in roosts by the hundreds, typically in deep cracks or niches in cliffs and large rocks. In the evening, they gather above a roost, ascending beyond view and then descending en masse, swirling in front of the roost site as individuals enter several abreast. Occasionally one misses, bouncing off the entrance to rejoin the swirling mass. The swifts nest in crevices in sheer cliffs, using their saliva to glue a little cup of twigs and moss to the vertical wall.

Aeronautes saxatalis	ORDER CAPRIMULGIFORMES	FAMILY APODIDAE / SWIFTS

Cool FACT

The White-throated Swift sometimes follows farm machinery to capture fleeing insects—a behavior common among gulls and swallows but not in most swifts.

Cool
FACT

The Ruby-throated Hummingbird beats its wings
about fifty-three times a second.

RUBY-THROATED HUMMINGBIRD

The Ruby-throated Hummingbird is eastern North America's sole breeding hummingbird. These tiny, precision-flying creatures hover at a flower, glittering like jewels in the sun, then zip away in a flash of green and red toward the next nectar source. Feeders and flower gardens are great ways to attract these brilliant-hued birds, and some people turn their yards into buzzing clouds of hummingbirds each summer. Enjoy them while they're around; by early fall they're bound for Central America. Many cross the Gulf of Mexico in a single flight, which they accomplish by gorging on nectar and insects to double their body mass before setting out.

Archilochus colubris	**ORDER** CAPRIMULGIFORMES	**FAMILY** TROCHILIDAE / HUMMINGBIRDS

BLACK-CHINNED HUMMINGBIRD

This small, green-backed hummingbird of the West has a thin strip of iridescent purple bordering its black chin, visible only when light hits it just right. Black-chinned Hummingbirds are exceptionally widespread, found from deserts to mountain forests; many winter along the Gulf Coast. They adapt easily to urban residential areas and are attracted to feeders; you may see them perched at the very top of a bare branch. In flight, their wings produce a low-pitched hum.

When feeding, the bird extends its tongue through a nearly closed bill about thirteen to seventeen times each second. Nectar moves through two grooves in the tongue via capillary action; when the tongue retracts, nectar is squeezed into the mouth. In this way, the hummingbird consumes about a fifth of a fluid ounce in an average meal. In cold weather, it may eat three times its body weight in nectar in one day, but it can survive without nectar when insects are plentiful.

Archilochus alexandri	ORDER CAPRIMULGIFORMES	FAMILY TROCHILIDAE / HUMMINGBIRDS

Cool
FACT

A Black-chinned Hummingbird's eggs are about the size of a coffee bean. The nest, made of plant down and spider and insect silk, expands as the babies grow.

ANNA'S HUMMINGBIRD

Anna's Hummingbirds are among the most common of their kind along the Pacific Coast, though anything but common in appearance. With iridescent emerald feathers and sparkling, rose pink throats, they look more like flying jewelry than birds. For a creature no larger than a ping-pong ball and no heavier than a nickel, the Anna's Hummingbird makes a strong impression. In a thrilling courtship display, males climb up to 130 feet into the air and then swoop to the ground with a curious burst of noise produced through their tail feathers.

Found only in the New World, hummingbirds fascinated the first Europeans to arrive on the continent. Christopher Columbus wrote about them, and some wondered if they were a cross between a bird and an insect. Later, their feathers became fashionable ornaments in Europe—thankfully, the practice fell out of favor. This species was named in 1829 by a French naturalist who studied specimens owned by the duke and duchess of Rivoli: her name was Anna.

Calypte anna	**ORDER** CAPRIMULGIFORMES	**FAMILY** TROCHILIDAE / HUMMINGBIRDS

Cool FACT On rare occasions, bees and wasps may become impaled on the bill of an Anna's Hummingbird, causing the bird to starve to death.

BELTED KINGFISHER

With its top-heavy physique, ragged crest, energetic flight, and piercing rattle of a call, the Belted Kingfisher projects an air of great confidence as it patrols rivers and shorelines. It nests in burrows along earthen banks and feeds almost entirely on aquatic prey, diving to catch fish and crayfish with its heavy, straight bill. Its basic coloring is powdery blue-gray with a white breast; males have a blue band across the breast, and on females the band is blue and chestnut.

The Belted Kingfisher's breeding distribution is limited in some areas by the availability of suitable nesting sites. Human activity, such as road building and digging gravel pits, has created banks where kingfishers can nest and allowed the bird's breeding range to expand.

Megaceryle alcyon	ORDER CORACIIFORMES	FAMILY ALCEDINIDAE / KINGFISHERS

Cool FACT

The Belted Kingfisher is one of the few bird species
in which the female is more brightly colored
than the male. Among the nearly one hundred species
of kingfishers, the sexes often look alike.

RED-HEADED WOODPECKER

The gorgeous Red-headed Woodpecker has an entirely cherry-red head, a snow white body, and wings that are half white, half inky black—bold patterning that suggested the nickname "flying checkerboard." Unlike most woodpeckers, which hunt insects on tree trunks, they're adept at catching insects in the air. They also eat lots of acorns and beechnuts, often hiding extra food in tree crevices for later. This magnificent species has declined severely in the past half century because of habitat loss and changes to its food supply.

The Red-headed Woodpecker is one of only four North American woodpeckers known to store food and the only one known to cover stored food with wood or bark. It hides insects and seeds in cracks in wood, under bark, in fence posts, and under roof shingles. Grasshoppers are sometimes stored alive but wedged into crevices so tightly that they cannot escape.

Melanerpes erythrocephalus	ORDER PICIFORMES	FAMILY PICIDAE / WOODPECKERS

Cool FACT

Red-headed Woodpeckers are fierce defenders of their territory. They may remove the eggs of other species from nests and nest boxes, destroy other birds' nests, and even enter duck nest boxes and puncture the duck eggs.

ACORN WOODPECKER

Acorn Woodpeckers live in large groups in western oak or pine–oak woodlands. Their social lives are endlessly fascinating: they live communally and store thousands of acorns each year by jamming them into specially made holes in "granary" trees. A member of the group is always on alert to guard the hoard from thieves, while others race through the trees giving parrotlike *waka-waka* calls. Their breeding behavior is equally complicated: multiple males and females join forces to raise young in a single nest. This woodpecker tends not to migrate.

In 1923, American ornithologist William Leon Dawson called the dapper Acorn Woodpecker "our native aristocrat." Dawson wrote: "He is unruffled by the operations of the human plebs in whatever disguise. . . . Wigwams, haciendas, or university halls, what matter such frivolities, if only one may go calmly on with the main business of life, which is indubitably the hoarding of acorns."

Melanerpes formicivorus	**ORDER** PICIFORMES	**FAMILY** PICIDAE / WOODPECKERS

Cool FACT

The Acorn Woodpecker will store acorns in human-made structures, drilling holes in fenceposts, utility poles, buildings, and even automobile radiators. Occasionally, the bird will stash acorns in places where it cannot get them out. Woodpeckers once put 485 pounds of acorns into a wooden water tank in Arizona.

RED-BELLIED WOODPECKER

Red-bellied Woodpeckers are pale, medium-sized woodpeckers common in forests throughout the East. As the species name *carolinus* implies, they formerly inhabited chiefly the Southeast, but in recent decades their range has expanded northward and westward. Their strikingly barred backs and gleaming red caps (more of a neck patch on females) make them an unforgettable sight—just resist the temptation to call them Red-headed Woodpeckers, a species that has an entirely red head. Learn the Red-bellied's rolling call, and you'll notice these birds everywhere.

You may see Red-bellied Woodpeckers wedge large nuts into bark crevices, then use their beaks to whack them into manageable pieces. They also store food in cracks in trees and fence posts, a habit shared with other woodpeckers in its genus. They readily come to feeders.

Melanerpes carolinus	ORDER **PICIFORMES**	FAMILY **PICIDAE / WOODPECKERS**

Cool FACT

Now and then you see a Red-bellied Woodpecker flying fast and erratically through the forest, abruptly changing direction, alighting for an instant and immediately taking off again, keeping up a quick chatter of calls. Scientists categorize this odd behavior as a type of play that probably helps young birds practice evasive actions they may one day need.

YELLOW-BELLIED SAPSUCKER

On a walk through an eastern forest, you might spot rows of shallow holes in tree bark. This is the work of the Yellow-bellied Sapsucker, an enterprising woodpecker that laps up the leaking sap and any trapped insects with its specialized, brush-tipped tongue. Sharply attired in barred black and white, with a red cap and (in males) red throat, these birds sit still on tree trunks for long intervals while feeding. To find one, listen for their loud mewing calls or stuttered drumming.

The Yellow-bellied Sapsucker makes two kinds of holes to harvest sap. Round holes extend deep in the tree; the sapsucker inserts its bill into these holes to probe for sap. It also makes shallower rectangular holes, which must be maintained continually for the sap to flow. The bird licks the sap from these holes and eats the cambium of the tree as well. New holes usually are made in a line with old holes or in a new line above the old.

Sphyrapicus varius	ORDER **PICIFORMES**	FAMILY **PICIDAE / WOODPECKERS**

Cool FACT

Yellow-bellied Sapsuckers have been found drilling sap wells in more than a thousand species of trees and woody plants, though they show a strong preference for birches and maples.

DOWNY WOODPECKER

The active little Downy Woodpecker is a familiar sight at backyard feeders and in parks and woodlots, where it joins flocks of chickadees and nuthatches—birds not much smaller than the woodpecker. An acrobatic forager, this black-and-white woodpecker is at home on tiny branches or balancing on slender plant galls, sycamore seed balls, and suet feeders. Downies and their larger look-alike, the Hairy Woodpecker, present one of the first identification challenges that beginning birdwatchers master.

Male and female Downy Woodpeckers divide up where they look for food in winter. Males tend to feed on small branches and weed stems, and females feed on larger branches and trunks. The males keep females from foraging in the more productive spots; when researchers removed males from a woodlot, females responded by feeding along smaller branches.

Dryobates pubescens	ORDER PICIFORMES	FAMILY PICIDAE / WOODPECKERS

Cool FACT

Downy Woodpeckers have been discovered nesting inside the walls of buildings.

RED-COCKADED WOODPECKER

The Red-cockaded Woodpecker is a habitat specialist of the Southeast's once-vast longleaf pine stands. Its habitat—old pines with very little understory—was shaped by the region's frequent lightning fires. The birds also occur in stands of loblolly, slash, and other pine species. They excavate cavities in living pines softened by heartwood rot and live in family groups that work together to dig cavities and raise young.

The species declined drastically as its original habitat was cut down, and the species was listed as endangered in 1970. Thus began a long struggle between conservationists and timber interests, involving multiple recovery plans, court cases, and the use of innovative techniques such as prescribed burns, installing artificial nest cavities, and "safe harbor" agreements with private landowners. Red-cockadeds have rebounded in number, but the species is still listed because it likely won't survive without human management.

Dryobates borealis	ORDER PICIFORMES	FAMILY PICIDAE / WOODPECKERS

Cool FACT

A cockade is a ribbon or ornament worn on a hat. The "cockade" of the Red-cockaded Woodpecker is a tiny red patch on the side of the male's head. It may be hidden and is very difficult to see in the field.

NORTHERN FLICKER

Northern Flickers are large, brown woodpeckers with a gentle expression and handsome black-scalloped plumage. On woodland walks, don't be surprised if you scare one up from the ground. It's not where you'd expect to find a woodpecker, but flickers eat mainly ants and beetles, digging for them with their unusual, slightly curved bill. When they fly, you'll see a flash of color in the wings—yellow if you're in the East, red if you're in the West—and a bright white flash on the rump.

The red-shafted and yellow-shafted forms of the Northern Flicker formerly were considered different species. The two forms hybridize extensively in a wide zone from Alaska to the panhandle of Texas. A hybrid often has some traits from each of the two forms.

Colaptes auratus	ORDER **PICIFORMES**	FAMILY **PICIDAE / WOODPECKERS**

Cool **FACT**

The Northern Flicker is among the few North American woodpeckers that is strongly migratory. Flickers in the northern parts of their range move south for the winter, although a few individuals may stay quite far north.

PILEATED WOODPECKER

The Pileated Woodpecker is one of the biggest, most striking forest birds on the continent, found over much of North America. It's nearly the size of a crow but leaner, black with bold white stripes down the neck and a backswept, flaming-red crest.

Look (and listen) for Pileated Woodpeckers whacking at dead trees and fallen logs in search of their main prey, carpenter ants; or you may spot the unique rectangular holes it makes in the wood. The nest holes these birds make offer crucial shelter to many species including swifts, owls, ducks, bats, and pine martens. They rarely migrate, and a pair defends its territory year-round; a pair member will not abandon a territory even if its mate is lost.

Dryocopus pileatus	ORDER PICIFORMES	FAMILY PICIDAE / WOODPECKERS

Cool FACT

The Pileated Woodpecker digs characteristically rectangular holes in trees to find ants. These excavations can be broad and deep enough to cause small trees to break in half.

AMERICAN KESTREL

North America's littlest falcon, the American Kestrel packs a predator's fierce intensity into its small body. It's one of the most colorful of all raptors: the male's slate blue head and wings contrast elegantly with his pinkish red back and tail; the female has the same warm reddish plumage on her wings, back, and tail. Hunting for insects and other small prey in open territory, kestrels perch on wires or poles, or hover facing into the wind, flapping and adjusting their long tails to stay in place. Kestrels are declining in parts of their range; you can help them by putting up nest boxes.

It can be tough being a small bird of prey. Despite their fierce lifestyle, American Kestrels can end up as prey themselves for larger birds such as Northern Goshawks, Red-tailed Hawks (page 100), Barn Owls (page 144), American Crows (page 210), and Sharp-shinned and Cooper's Hawks (page 90), as well as for rat snakes, corn snakes, and even fire ants.

Falco sparverius	**ORDER** **FALCONIFORMES**	**FAMILY** **FALCONIDAE / FALCONS & CARACARAS**

Cool **FACT**

Sports fans in some cities get an extra show during night games: kestrels may perch on light standards or foul poles, tracking moths and other insects in the powerful stadium light beams and catching these snacks on the wing. Some of their hunting flights have even made it onto TV sports coverage.

PEREGRINE FALCON

Powerful and fast-flying, the Peregrine Falcon hunts medium-sized birds, dropping down on them from on high in a spectacular *stoop*. In the mid-twentieth century, Peregrines were virtually eradicated from eastern North America by pesticide poisoning. After significant recovery efforts, they have made an incredible comeback and are now regularly seen in many large cities and coastal areas.

People have trained falcons as hunting partners for more than a thousand years, and the Peregrine has always been a prized bird. Efforts to breed the species in captivity and reestablish populations depleted during the DDT years were greatly aided by the methods developed by falconers to handle captive falcons.

Falco peregrinus	**ORDER** **FALCONIFORMES**	**FAMILY** **FALCONIDAE / FALCONS & CARACARAS**

Cool **FACT**

The Peregrine Falcon is a very fast flier, averaging twenty-five to thirty-four miles an hour in traveling flight, and reaching speeds up to sixty-nine miles an hour in direct pursuit of prey. During its spectacular hunting stoop, from heights of more than a half mile, the Peregrine may reach two hundred miles an hour as it drops toward its prey.

EASTERN PHOEBE

One of our most familiar eastern flycatchers, the Eastern Phoebe is known for its raspy *fee-bee* call, frequently heard around yards and farms in spring and summer. These brown and white songbirds sit upright and wag their tails from prominent, low perches. They typically place their mud and grass nests in protected nooks on bridges, barns, and houses, which helps make the species familiar to humans. Hardy birds, Eastern Phoebes winter farther north than most other flycatchers and are among the earliest returning migrants in spring.

The Eastern Phoebe is a loner, rarely coming in contact with other phoebes. Even members of a mated pair do not spend much time together. They may roost together early in pair formation, but even during egg laying, the female frequently chases the male away from her.

Sayornis phoebe	**ORDER** PASSERIFORMES	**FAMILY** TYRANNIDAE / TYRANT FLYCATCHERS

Cool **FACT**

In 1804, the Eastern Phoebe became the first banded bird in North America. Audubon attached silvered thread to an Eastern Phoebe's leg to track its return in successive years.

SAY'S PHOEBE

Like other phoebes, the Say's Phoebe seems undaunted by humans and often nests on buildings. These open-country birds have cinnamon-washed underparts and a rather gentle expression. They sally from low perches to snatch insects in midair or pounce on them on the ground. Say's Phoebes often pump their tails while perched on a wire, fence post, or low bush. They breed farther north than any other flycatcher, seemingly limited only by a lack of nest sites.

Charles Lucien Bonaparte named the Say's Phoebe after the American naturalist Thomas Say—the first scientist to encounter the bird, at a site near Cañon City, Colorado, in 1819. During the same expedition, Say also collected ten additional bird species. Despite finding several new bird species during his career, Say is perhaps better known as the father of American entomology.

Sayornis saya	**ORDER** **PASSERIFORMES**	**FAMILY** **TYRANNIDAE / TYRANT FLYCATCHERS**

Cool **FACT**

Say's Phoebes have been in the United States for a long time. Paleontologists have discovered Say's Phoebe fossils, dating back about four hundred thousand years (the late Pleistocene), in Arizona, California, New Mexico, and Texas.

ASH-THROATED FLYCATCHER

Colorwise, with a pale lemon belly and cinnamon tail, the Ash-throated Flycatcher is reminiscent of a desert just before sunset. Its subtle hues help it blend into its surroundings, but its lively, sputtering calls, given throughout the morning, give away its location. In what looks like curiosity, this flycatcher tips its head side to side while perched among low oaks and mesquite trees. This species migrates between the western states and Central America; breeders arriving north early in the spring may raise two broods in one season.

The trick to finding an Ash-throated Flycatcher is to listen for its distinctive *ka-brick* call in dry, open woodlands and scrub. Heading out early in the morning will increase your chances of finding one, as they, like other desert dwellers, tend to quiet down as soon as the sun starts heating things up.

Myiarchus cinerascens	ORDER **PASSERIFORMES**	FAMILY **TYRANNIDAE / TYRANT FLYCATCHERS**

Like many other desert animals such as the kangaroo rat, Ash-throated Flycatchers don't need to drink water. Instead they get it from the insects and spiders they eat.

GREAT CRESTED FLYCATCHER

A large, assertive flycatcher with rich reddish brown accents and a lemon yellow belly, the Great Crested Flycatcher is a common bird of eastern woodlands. Its habit of hunting high in the canopy means it's not particularly conspicuous—until you learn its distinctive call, an emphatic rising whistle. These flycatchers swoop after flying insects and may crash into foliage in pursuit of leaf-crawling prey. They are the only eastern flycatchers that nest in cavities, and this means they sometimes make use of nest boxes.

Great Crested Flycatchers weave shed snakeskin into their nests. Where it's readily available, as in Florida, nearly every nest contains snakeskin. They seem to look for flimsy, crinkly nest materials—they've also been known to use onion skins, cellophane, or plastic wrappers.

Myiarchus crinitus	**ORDER** **PASSERIFORMES**	**FAMILY** **TYRANNIDAE / TYRANT FLYCATCHERS**

Cool FACT

The Great Crested Flycatcher is a bird of the treetops, spending very little time on the ground. When on the ground, it prefers to fly from place to place rather than hop or walk.

EASTERN KINGBIRD

With dark gray upperparts and a neat white tip on its tail, the Eastern Kingbird looks like it's wearing a business suit. And this big-headed, broad-shouldered bird does mean business—just watch one harassing crows, Red-tailed Hawks (page 100), Great Blue Herons (page 66), and other birds that pass over its territory. Kingbirds often perch on wires in open areas, sallying out to hunt flying insects or fluttering slowly over the tops of grasses. They spend winters in South American forests, where they eat mainly fruit.

The scientific name *Tyrannus* (tyrant or king) refers to the aggression kingbirds exhibit toward each other and other species. When defending their nests, they will attack much larger predators like hawks, crows, and squirrels. They have been known to knock unsuspecting Blue Jays out of trees.

Tyrannus tyrannus	ORDER **PASSERIFORMES**	FAMILY **TYRANNIDAE / TYRANT FLYCATCHERS**

Cool FACT

Kingbirds sometimes catch small frogs, treating them the same way they deal with large insects: beating them against a perch and swallowing them whole. Eastern Kingbirds apparently rely almost completely on eating prey or fruit for moisture; they are rarely seen drinking water.

SCISSOR-TAILED FLYCATCHER

A sleek gray and salmon-pink flycatcher equipped with an absurdly long tail, the Scissor-tailed Flycatcher often sits on fence wires in the south-central United States. They typically perch in the open, where the long, forked tail makes an unmistakable silhouette. That tail lends balance as the birds expertly catch insects on the wing, twisting and turning sharply in midair. In late summer and early fall, Scissor-tails gather in large, bickering flocks as they prepare to migrate to Mexico and Central America.

A member of the kingbird genus *Tyrannus*, Scissor-tailed Flycatchers resemble other kingbirds in behavior, voice, and morphology. Only one other *Tyrannus* species—the Fork-tailed Flycatcher—has a dramatically long tail, however.

Tyrannus forficatus	**ORDER** **PASSERIFORMES**	**FAMILY** **TYRANNIDAE / TYRANT FLYCATCHERS**

Cool FACT

The Scissor-tailed Flycatcher uses many human-made products in its nest, such as string, cloth, paper, carpet fuzz, and cigarette filters. One study of nests in an urban area in Texas found that artificial materials accounted for 30 percent of the weight of nests.

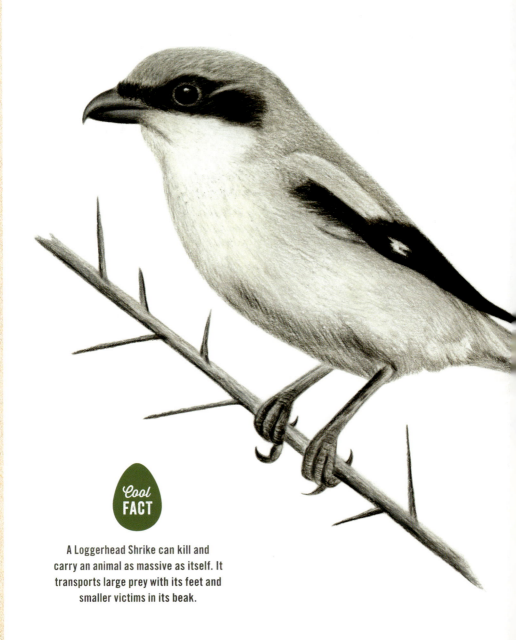

A Loggerhead Shrike can kill and carry an animal as massive as itself. It transports large prey with its feet and smaller victims in its beak.

LOGGERHEAD SHRIKE

The Loggerhead Shrike is a songbird with a raptor's habits. A denizen of grasslands and other open habitats throughout much of North America, this black-masked, gray and white predator hunts from utility poles, fence posts, and other conspicuous perches, preying on insects, birds, lizards, and small mammals. Lacking a raptor's talons, Loggerheads—named for their blocky head shape—skewer their kills on thorns or barbed wire or wedge them into tight places for caching (storing) them for later consumption, like some woodpeckers store acorns. Its numbers have dropped sharply in the last half century as land-use practices changed.

Newly fledged Loggerhead Shrikes perform exaggerated versions of adult hunting behavior. They peck at inanimate objects, fly about with leaves or sticks in their beaks, practice aerial chases without a target, or chase after their parents. They also perform rudimentary impaling gestures, grasping objects in their bill and repeatedly touching them to a branch or perch, as if trying to get them to stick.

Lanius ludovicianus
ORDER
PASSERIFORMES
FAMILY
LANIIDAE / SHRIKES

BELL'S VIREO

A tireless little bird of thickets and thorn scrub, the Bell's Vireo nests from the Midwest through the Southwest and into northern Mexico. Although plain in plumage, males sing so energetically and distinctively that it's hard to overlook them during breeding season. However, with continued loss of its preferred habitats across the continent—riparian areas, brushy fields, young second-growth woodland, and mesquite brushlands—the species has become scarce in many places where it was once common.

John James Audubon was the first naturalist to notice and formally describe Bell's Vireo, during his 1843 exploration of the Missouri River. He called it the greenlet and named it for his friend John Graham Bell, a taxidermist from Tappan, New York, who accompanied him on the expedition. (Bell's Sparrow is also named in his honor.) Bell taught the young Theodore Roosevelt how to prepare specimens of birds and mammals.

Vireo bellii	**ORDER** PASSERIFORMES	**FAMILY** VIREONIDAE / VIREOS, SHRIKE-BABBLERS & ERPORNIS

Cool **FACT**

No observation of a Bell's Vireo drinking water has ever been reported. It may be able to obtain all of the water that it needs from its food.

RED-EYED VIREO

A tireless songster, the Red-eyed Vireo is one of the most common summer residents of eastern forests. These neat, olive-green and white songbirds have a crisp head pattern of gray, black, and white. Their brief but incessant songs—sometimes more than twenty thousand a day by a single male—contribute to the characteristic sound of an eastern forest in summer. Not everyone is a fan of this vireo's monotonous vocalizing: Bradford Torrey in 1889 reflected wryly, "I have always thought that whoever dubbed this vireo the 'preacher' could have had no very exalted opinion of the clergy."

When fall arrives, Red-eyed Vireos head for the Amazon basin, fueled by a summer of plucking caterpillars from leaves in the treetops.

Vireo olivaceus	**ORDER** **PASSERIFORMES**	**FAMILY** **VIREONIDAE / VIREOS, SHRIKE-BABBLERS & ERPORNIS**

Cool **FACT**

The red iris that gives the species its name doesn't develop until the end of the birds' first winter. Then the brown iris becomes a dull brick red to bright crimson, depending on the individual.

STELLER'S JAY

A large, dark jay of evergreen forests in the mountainous West, the Steller's Jay is common in forest wildernesses—but it's also a fixture of campgrounds, parklands, and backyards, where it is quick to spy bird feeders or unattended picnic items. When patrolling the woods, Steller's Jays stick to the high canopy, but you'll hear their harsh, scolding calls if any are nearby. Graceful and almost lazy in flight, they fly with long swoops of their broad, rounded wings.

This jay holds the dubious honor of being perhaps the most frequently misspelled name in the bird lexicon. Up close, its dazzling mix of azure and blue is undoubtedly stellar, but that's not how you spell the name. The species was discovered on an Alaskan island in 1741 by Georg Steller, a naturalist on a Russian explorer's ship. When it was officially described in 1788, it was named after him—along with other discoveries including the Steller's sea lion and Steller's Sea-Eagle.

Cyanocitta stelleri	**ORDER** **PASSERIFORMES**	**FAMILY** **CORVIDAE / CROWS, JAYS & MAGPIES**

Cool **FACT**

An excellent mimic with a large repertoire, the Steller's Jay can imitate birds, squirrels, cats, dogs, chickens, and some mechanical objects.

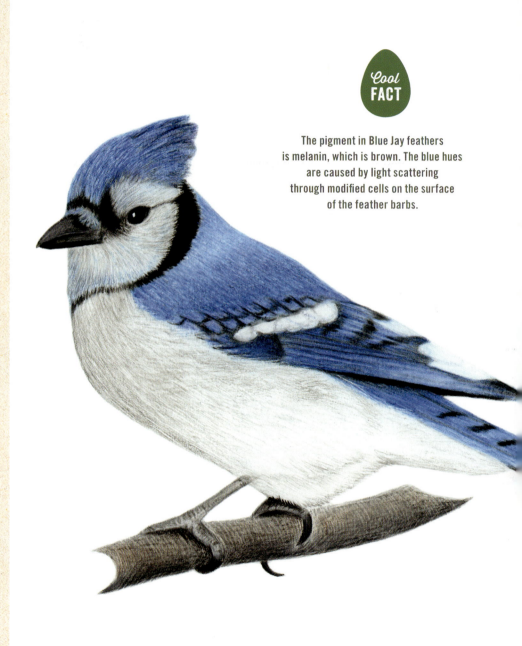

The pigment in Blue Jay feathers
is melanin, which is brown. The blue hues
are caused by light scattering
through modified cells on the surface
of the feather barbs.

BLUE JAY

This common large songbird is familiar to many people. In countless backyards across North America, it is instantly recognized by its jaunty crest, distinctive plumage of blue, black, and white—and by its harsh calls. Like other corvids, Blue Jays are known for their intelligence and complex social systems with tight family bonds. Their fondness for acorns is credited with helping to spread oak trees after the last glacial period. The Blue Jay attitude was described in 1831 by Alexander Wilson: the bird is "distinguished as a kind of beau among feathered tenants of our woods, by the brilliancy of his dress; and like most other coxcombs, makes himself still more conspicuous by his loquacity. . . ."

Thousands of Blue Jays migrate in flocks along the Great Lakes and Atlantic coasts, but much about their migration remains a mystery. Some are present all through the winter in all parts of their range. Young jays may be more likely to migrate than adults, but many adults also do. Some individual jays migrate south one year, stay north the next winter, then fly south again the next year. No one has worked out why they migrate when they do.

Cyanocitta cristata

ORDER

PASSERIFORMES

FAMILY

CORVIDAE / CROWS, JAYS & MAGPIES

Cool FACT

The Black-billed Magpie's large nest can take up to forty days to construct. It's a lot of work, but a study found that nest building used only about 1 percent of a mated pair's daily energy expenditure. Creating eggs, on the other hand, takes 23 percent of the female's daily energy budget.

BLACK-BILLED MAGPIE

Black-billed Magpies are familiar and entertaining birds of western North America. They sit on fence posts and road signs or flap across rangelands, their white wing patches flashing and their very long tails trailing behind. This large, flashy relative of jays and crows is a social creature, gathering in numbers to feed at carrion.

Historical records of the American West indicate that Black-billed Magpies have associated with people for a long time. Magpies frequently followed hunting parties of Plains Indians and fed on leftovers from bison kills. On their expedition to the Pacific, Lewis and Clark reported magpies boldly entering their tents to steal food.

Pica hudsonia
ORDER
PASSERIFORMES
FAMILY
CORVIDAE / CROWS, JAYS & MAGPIES

CLARK'S NUTCRACKER

High in the mountains of the West, gray and black Clark's Nutcrackers swoop among majestic pine trees, flashing white in their wings and short tail. They use their daggerlike bills to rip into pine cones and pull out large seeds, which they stash in a pouch under their tongue and then carry away to bury for the winter.

Each bird buries tens of thousands of seeds each summer and somehow remembers the locations of most of them. Males help females incubate eggs, allowing the female to retrieve seeds from her caches. Seeds they don't retrieve play a crucial role in growing new pine forests.

Nucifraga columbiana	**ORDER** **PASSERIFORMES**	**FAMILY** CORVIDAE / CROWS, JAYS & MAGPIES

Cool FACT

Ounce for ounce, the seeds of the whitebark pine—one of the species that Clark's Nutcrackers depends on—have more calories than chocolate.

AMERICAN CROW

American Crows are familiar over much of the continent: large, intelligent, all-black birds with hoarse, cawing voices. They are a common sight in treetops and fields and on roadsides, and in habitats ranging from open woods and empty beaches to town centers. They usually feed on the ground and eat almost anything—typically earthworms, insects and other small animals, seeds, and fruit but also garbage, carrion, and chicks they steal from nests. Their flight style is distinctive: a patient, methodical flapping that's rarely broken up with glides.

In winter, American Crows congregate in large numbers to sleep in communal roosts—from a few hundred up to two million crows. Certain roosts have been forming in the same general area for well over a century. In the last few decades, some roosts have moved into urban areas, where the noise and mess cause conflicts with people.

Corvus brachyrhynchos	**ORDER** PASSERIFORMES	**FAMILY** CORVIDAE / CROWS, JAYS & MAGPIES

Cool **FACT**

Crows sometimes make and use tools. Examples include a captive crow using a cup to carry water to a bowl of dry mash, shaping a piece of wood and using it to probe a hole in a fence post in search of food, and breaking off pieces of pinecone to drop on tree climbers too near a nest.

FISH CROW

Almost identical in looks to the ubiquitous American Crow, and sharing much of its range in the East, Fish Crows are tough to identify until you learn their nasal calls. Look for them around bodies of water, usually in flocks and sometimes with American Crows. They are supreme generalists, eating just about anything they can find, and have adapted well to living with people. In recent decades, Fish Crows have expanded their range inland and northward along major river systems.

When Fish Crows find a good source of food, they may cache the surplus for later. These hiding places can be in grass, clumps of Spanish moss, or crevices in tree bark. Nesting adults may use these caches when feeding their young.

Corvus ossifragus	**ORDER** PASSERIFORMES	**FAMILY** CORVIDAE / CROWS, JAYS & MAGPIES

Cool FACT

Fish Crows are inveterate nest robbers, raiding the nests of many kinds of waterbirds and songbirds, as well as finding and digging up turtle eggs. They also harass and steal food from crows, gulls, ibis, and Ospreys (page 82).

CHIHUAHUAN RAVEN

An all-black bird of hot, dry open country, the Chihuahuan Raven is partway between an American Crow and a Common Raven in size. It's better than either of those relatives at surviving in grasslands and deserts of the southwestern United States and northern Mexico. Like other corvids (members of the crow family), Chihuahuan Ravens are intelligent and social, often traveling and roosting in flocks. Once known as the White-necked Raven, this species does have white-based neck feathers, but this feature is very rarely seen in the field.

In the late 1800s and early 1900s, Chihuahuan Ravens were more widespread in Colorado and most of the adjacent states than they are now. Scientists speculate that the slaughter by settlers of the Plains bison provided ample food for ravens, encouraging a temporary range expansion for this intelligent bird.

Corvus cryptoleucus	ORDER **PASSERIFORMES**	FAMILY **CORVIDAE / CROWS, JAYS & MAGPIES**

Cool **FACT**

Unlike most crows and ravens, the Chihuahuan Raven frequently reuses its nest in subsequent years. Some pairs may maintain two nests, using them in alternate years.

The Common Raven is an acrobatic flier, often performing rolls and somersaults in the air. One bird was seen flying upside down for more than a half mile. Young birds play games with sticks, repeatedly dropping them, then diving to catch them in midair.

COMMON RAVEN

The legendary bird now known as the Common Raven has accompanied people around the Northern Hemisphere for centuries, following their wagons, sleds, sleighs, and hunting parties in hopes of a quick meal. Among the smartest of all birds, ravens are currently solving ever more complicated problems devised by ever more creative scientists. These big, sooty birds thrive among humans or in the back of beyond, moving across the sky on easy, flowing wingbeats and filling the empty spaces with their echoing croak. No surprise that they have figured in folklore and myths from the Pacific Northwest to Celtic and Norse cultures, and in the poetic imagination of Western writers like Edgar Allan Poe.

Their intelligence makes Common Ravens formidable predators. They sometimes work in pairs to raid seabird colonies, one bird distracting an incubating adult and the other waiting to grab an egg or chick as soon as it's exposed. They've been seen waiting in trees as ewes give birth, then attacking the newborn lambs.

Corvus corax	ORDER **PASSERIFORMES**	FAMILY **CORVIDAE / CROWS, JAYS & MAGPIES**

HORNED LARK

Look carefully at a bare, brown field, especially in winter, and you may be surprised to notice that it's crawling with little brown shapes. If you get near enough, you may see a neat yellow bird face with black mask and tiny black "horns" waving in the breeze. Horned Larks are widespread songbirds of fields, deserts, and tundra, where they forage for seeds and insects and sing a high, tinkling song. Though they are still common, they have undergone a sharp decline in the last half century as agricultural lands have become inhospitable. Loss of agricultural fields to reforestation and development, and human encroachment on the birds' habitat, are factors in their decline.

Horned Larks can live from sea level to an altitude of thirteen thousand feet, an unusually wide elevational range. Carl Linnaeus, the Swedish scientist who formalized the system of naming organisms (with genus and species), named this bird *Alauda alpestris*: "lark of the mountains" (it has since been moved to the genus *Eremophila*).

Eremophila alpestris	ORDER	FAMILY
	PASSERIFORMES	ALAUDIDAE / LARKS

Cool FACT

When she is ready to mate, a female Horned Lark performs a courting display that looks very much as if she is taking a dust bath. In fact, potential mates seem prone to confusion on this score: a male catching a glimpse of a dust-bathing female may attempt to mate with her.

PURPLE MARTIN

In the eastern part of North America, putting up a Purple Martin house is like installing a miniature neighborhood in your backyard: dark, glossy blue males and brown females will peer from the entrances and chirp from the rooftops all summer. In the West, martins mainly still nest the old-fashioned way—in woodpecker holes. Our largest swallows, Purple Martins perform aerial acrobatics to snap up flying insects. At the end of the breeding season, they gather in big flocks and make their way to South America.

Although the term "scout" is often used for the first returning Purple Martins, the earliest arriving individuals are not checking out the area to make sure it is safe for the rest of the group. Rather, they are older martins returning to areas where they have previously nested. Martins returning north to breed for their first time come back several weeks later. The advanced return of older individuals is a common occurrence among migratory bird species.

Progne subis	**ORDER** **PASSERIFORMES**	**FAMILY** **HIRUNDINIDAE / SWALLOWS**

Cool FACT

The Purple Martin not only gets all its food in flight—it gets all its water that way, too. It skims the surface of a pond and scoops up water with its lower bill.

TREE SWALLOW

Handsome aerialists, blue-green on the back and clean white in front, Tree Swallows are a familiar sight in summer fields and wetlands across northern North America. They chase after flying insects with acrobatic twists and turns, their iridescent upperparts flashing in the sunlight. Tree Swallows nest in tree cavities; they also readily take up residence in nest boxes. This habit has allowed scientists to study their breeding biology in detail, and it makes them a great addition to many a backyard or field where people are around to watch them.

Migrating and wintering Tree Swallows can form enormous flocks, numbering in the hundreds of thousands. They gather about an hour before sunset in a dense cloud above a roost site (such as a cattail marsh or grove of small trees), swirling around like a living tornado. With each pass, more birds drop down until all are settled on the roost.

Tachycineta bicolor	ORDER	FAMILY
	PASSERIFORMES	**HIRUNDINIDAE / SWALLOWS**

Cool FACT

Tree Swallows are among the best-studied birds in North America and have helped researchers make major advances in several branches of ecology. Still, we know little about their lives during migration and winter.

VIOLET-GREEN SWALLOW

Violet-green Swallows may look dark at first, but their true colors come to life when sunlight illuminates their metallic green back and iridescent purple rump. These aerial insectivores perform stunts high in the sky over lakes and streams in search of flying insects. They are a common sight in the West in spring and summer, but they vanish to Mexico and Central America for the winter. This swallow can be distinguished from others by its white cheeks and the white patches (or "saddlebags") on either side of its rump.

Late-hatching young are sometimes at a disadvantage, but female Violet-green Swallows invest more antimicrobial proteins in the eggs laid later within a clutch, possibly reducing the risk of infection for late-hatching young and giving them a leg up.

Tachycineta thalassina	**ORDER** **PASSERIFORMES**	**FAMILY** **HIRUNDINIDAE / SWALLOWS**

Cool **FACT**

Violet-green Swallows have been recorded flying at twenty-eight miles an hour—a pretty respectable speed, considering that the Peregrine Falcon, the fastest bird of prey, averages about twenty-five to thirty-four miles an hour in traveling flight.

BARN SWALLOW

Glistening cobalt blue above and tawny below, Barn Swallows dart gracefully over fields, barnyards, and open water in search of flying insect prey. Look for the long, deeply forked tail that streams out behind this agile flier and sets it apart from all other North American swallows. Barn Swallows often cruise low, flying just a few inches above the ground or water. True to their name, they build their cup-shaped mud nests almost exclusively on human-made structures.

Although the killing of egrets is often cited as inspiring the conservation movement in the United States, it was the impact on Barn Swallows of the millinery (hat-making) trade that prompted naturalist George Bird Grinnell to write his 1886 editorial in *Forest & Stream* decrying the waste of bird life. His essay led to the founding of the first Audubon Society.

Hirundo rustica	ORDER PASSERIFORMES	FAMILY HIRUNDINIDAE / SWALLOWS

Cool
FACT

Barn Swallow parents sometimes get help from other birds to feed their young. These "helpers at the nest" are usually older siblings from previous clutches, but unrelated juveniles may help as well.

CAROLINA CHICKADEE

Audubon named this bird while he was traveling in South Carolina. The curious Carolina Chickadee looks very much like a Black-capped Chickadee: black cap, black bib, gray wings and back, and whitish underside. Carolina and Black-capped Chickadees hybridize where their ranges overlap, but the two species probably diverged from a common ancestor more than 2.5 million years ago.

Carolina Chickadees associate in flocks during winter. Each member has a rank; once spring arrives, the highest-ranking individuals will nest within the flock's territory; lower-ranking birds must travel farther to successfully claim a territory. Throughout the year, members of pairs, families, and flocks communicate with one another constantly. Most members of a winter flock stay in the same flock all season, but some birds are "flock switchers."

Poecile carolinensis	ORDER **PASSERIFORMES**	FAMILY **PARIDAE / TITS, CHICKADEES & TITMICE**

Cool FACT

When Carolina and Black-capped Chickadees hybridize, the hybrid offspring can sing the songs of either species, or the song itself might be a hybrid.

MOUNTAIN CHICKADEE

In the dry evergreen forests of the mountainous West, the tiny Mountain Chickadee is a busy presence overhead. Often the nucleus in mixed flocks of small birds, Mountain Chickadees flit through high branches, hang upside down to pluck insects or seeds from cones, and direct their scolding *chick-a-dee* call apparently at anyone who will listen.

These western evergreen forests periodically suffer massive outbreaks of tree-killing insects such as bark beetles and needle miners. When this happens, it's "all you can eat" for Mountain Chickadees. During an outbreak of the lodgepole needle miner in Arizona, one chickadee was found with 275 of the tiny caterpillars in its stomach.

Poecile gambeli	**ORDER** **PASSERIFORMES**	**FAMILY** **PARIDAE / TITS, CHICKADEES & TITMICE**

Cool **FACT**

Studies suggest that a chickadee weighing a half ounce needs to eat about ten calories per day to survive. That's equivalent to about one-twentieth of an ounce of peanut butter.

JUNIPER TITMOUSE

The feisty Juniper Titmouse is a plain gray bird with a prominent black eye and a tuft of feathers on its head. What it lacks in color, it makes up for in attitude, and its scratchy chatter can be heard all year long in the pinyon-juniper woodlands of the interior West. These birds tend to be easy to find as they flit to and from trees or dangle upside down from thin branches. They are very similar to the Oak Titmouse and until 1996 were considered the same species (the Plain Titmouse), but they live in different habitats, as their names suggest.

Like many other members of the chickadee family, Juniper Titmice don't migrate, instead enduring harsh winters on their breeding grounds. One of the ways they survive the cold, virtually insect-free season is by storing seeds in tree crevices or other handy places.

Baeolophus ridgwayi	**ORDER** **PASSERIFORMES**	**FAMILY** **PARIDAE / TITS, CHICKADEES & TITMICE**

Cool **FACT**

The female Juniper Titmouse is reluctant to leave the nest when she is incubating eggs. If disturbed on the nest, she will often hiss like a snake and refuse to move.

TUFTED TITMOUSE

A little gray bird with a big voice, the Tufted Titmouse is common in eastern deciduous forests and a frequent visitor to feeders. Large black eyes, a small, round bill, and a bushy crest give these birds an eager expression that matches the way they flit through canopies, hang from twig ends, and assert themselves at bird feeders. When a titmouse finds a large seed, you may see it carry the prize to a perch and crack it with sharp whacks of its stout bill.

Tufted Titmice hoard food in fall and winter, a behavior they share with many of their relatives, including chickadees and tits. Titmice take advantage of a bird feeder's bounty by storing many of the seeds they get. Usually its storage sites are within 130 feet of the feeder. The bird takes only one seed per trip and usually shells seeds before hiding them.

Baeolophus bicolor	**ORDER** **PASSERIFORMES**	**FAMILY** **PARIDAE / TITS, CHICKADEES & TITMICE**

Cool **FACT**

Tufted Titmice often line the inner cup of their nest with hair, sometimes plucked directly from living animals. Based on hair types found in old nests, the sources include raccoons, opossums, mice, woodchucks, squirrels, rabbits, livestock, pets, and even humans.

BUSHTIT

Bushtits are sprightly, social songbirds that twitter as they fly weakly between shrubs and thickets in western North America. Almost always found in lively flocks, these tiny birds move constantly, often hanging upside down to pick at insects or spiders on the undersides of leaves. Flocks of Bushtits mix with similar small songbirds like warblers, chickadees, and kinglets while foraging.

Male and female bushtits together weave a very unusual hanging nest, shaped like a soft pouch or sock, from moss, spiderwebs, and grasses—a process that can take a month or more.

Psaltriparus minimus	**ORDER** **PASSERIFORMES**	**FAMILY** **AEGITHALIDAE / LONG-TAILED TITS**

Cool FACT

The Bushtit is the only member of its family found in the Americas; ten other species live in Eurasia. All have similar complex hanging nests.

RED-BREASTED NUTHATCH

An intense bundle of energy at your feeder, the Red-breasted Nuthatch is a tiny, active bird of northern woods and western mountains. These long-billed, short-tailed songbirds travel through tree canopies with chickadees, kinglets, and woodpeckers, searching bark furrows for hidden insects. To spot them, look along trunks and branches of trees for a bird wandering up, down, and sideways over the bark. Their excited *yank-yank* calls sound like tiny tin horns up in the treetops.

While building a nest, the Red-breasted Nuthatch is aggressive, chasing away other hole-nesting birds such as the House Wren (page 240), White-breasted Nuthatch (page 236), and Downy Woodpecker (page 176). A particularly feisty nuthatch may also go after Yellow-rumped Warblers (page 278), House Finches (page 334), Violet-green Swallows (page 222), and Cordilleran Flycatchers.

	ORDER	FAMILY
Sitta canadensis	PASSERIFORMES	SITTIDAE / NUTHATCHES

Cool FACT

Red-breasted Nuthatches sometimes steal nest-lining material from the nests of other birds, including Pygmy Nuthatches (page 238) and Mountain Chickadees (page 228).

Cool FACT

If you see a White-breasted Nuthatch making lots of quick trips to and from your feeder—too many for it to be eating all those seeds—it may be storing seeds by wedging them into furrows in the bark of nearby trees.

WHITE-BREASTED NUTHATCH

A common feeder bird, the active and agile White-breasted Nuthatch has clean blue, black, gray, and white markings, along with an appetite for insects and large, meaty seeds. Nuthatches get their name from their habit of jamming large nuts and acorns into tree bark, then whacking them with their sharp bill to "hatch" out the seed from inside. These birds may be small but their voices are loud, and their insistent nasal yammering can lead you right to them.

The White-breasted Nuthatch is normally territorial throughout the year, with pairs staying together. The male must spend more time looking out for predators when he is alone than when his mate is on hand. That's the pattern for most birds and one reason why birds spend so much time in flocks. For her part, the female nuthatch has to put up with the male pushing her aside from foraging sites.

Sitta carolinensis	ORDER PASSERIFORMES	FAMILY SITTIDAE / NUTHATCHES

PYGMY NUTHATCH

Small even by nuthatch standards, Pygmy Nuthatches are tiny bundles of hyperactive energy that climb up and down ponderosa pines, trading *rubber-ducky* calls with their flockmates. The bird's buff to white underparts set off a slate gray back, and its grayish brown head bears a sharp, straight bill. Pygmy Nuthatches breed in large, extended family groups; you'll often see a half dozen at a time. Look for them in open forests of older ponderosa pines across the West.

The Pygmy Nuthatch is one of only a few songbirds in North America (and only two nuthatch species worldwide) that has nest helpers. Breeding pairs often get assistance from relatives—including their own grown offspring—when raising a young brood. The helpers defend the nest and feed incubating females and chicks.

Sitta pygmaea	ORDER **PASSERIFORMES**	FAMILY **SITTIDAE / NUTHATCHES**

Cool FACT

No records exist of Pygmy Nuthatches roosting alone. They always huddle in groups. In the 1950s, a biologist watched 150 Pygmy Nuthatches pile into roost holes in a single tree—at least 100 in a single hole.

HOUSE WREN

A plain brown bird with an effervescent voice, the House Wren is common in backyards over nearly all of the Americas. Listen for its *rush-and-jumble* song in summer, and you'll find this species zipping through shrubs and low tree branches, snatching at insects. As with all wrens, its round body and uptilted tail are trademarks. House Wrens will gladly use nest boxes, or you may find their twig-filled nests in old cans, boots, or boxes lying around in your garage. Wrens also love brush piles for cover and as a source of insects. If you need to prune trees or cut brush in your yard, consider heaping the cuttings into a pile as a safe place for birds to gather.

The House Wren has one of the largest ranges of any songbird in the New World. It breeds from Canada through the West Indies and Central America, and southward to the southernmost point of South America.

Troglodytes aedon	ORDER **PASSERIFORMES**	FAMILY **TROGLODYTIDAE / WRENS**

Cool FACT

Temperature inside the nest box can be critical to the survival of House Wren eggs. If a sun-drenched nest box warms above about 106 degrees F for an hour, the eggs will begin to die. If a cold snap chills a nest below about sixty-five degrees F for more than a day, this can also doom the eggs.

MARSH WREN

The pugnacious Marsh Wren clings to wetland vegetation, tail cocked and legs splayed—often with each foot wrapped around a different stalk. This rusty brown wren has black-and-white streaks down its back and a white eyebrow. It sings a rapid-fire gurgling, trilling, or buzzy song from the depths of the marshes where its secretive life unfolds.

Under the cover of reeds, males routinely mate with two or more females and build at least six dummy nests for every female they mate with. Why? Per several theories, they may serve as spares if a nest is destroyed, shelter for newly fledged young, decoys for predators, or they may signal the male's vigor and good taste in territory. Both males and females also destroy eggs and nestlings of other Marsh Wrens and marsh-nesting birds.

Cistothorus palustris	ORDER **PASSERIFORMES**	FAMILY **TROGLODYTIDAE / WRENS**

Cool **FACT**

Marsh Wrens are boisterous songsters, singing not only at dawn and dusk but sometimes throughout the night.

CAROLINA WREN

In summer, it can seem as if every patch of woods in the eastern United States rings with the rolling song of the Carolina Wren. This shy bird can be hard to see, but it delivers an amazing number of decibels for its size. Follow its *teakettle teakettle!* and other piercing exclamations through backyard or forest, and you may be rewarded with glimpses of this bird's rich cinnamon plumage, white eyebrow stripe, and long, upward-cocked tail. This hardy bird has been wintering farther and farther north in recent decades.

The Carolina Wren is sensitive to cold weather, however, and the northern populations decrease markedly after severe winters. Gradually warming winter temperatures over the last century may have been responsible for the northward range expansion seen since the mid-1900s.

Thryothorus ludovicianus	ORDER **PASSERIFORMES**	FAMILY **TROGLODYTIDAE / WRENS**

Cool **FACT**

One captive male Carolina Wren sang nearly three thousand times in a single day.

BEWICK'S WREN

If you come across a noisy, hyperactive little bird with bold white eyebrows, flicking its long tail as it hops from branch to branch, you may have spotted a Bewick's Wren. These master vocalists belt out a string of short whistles, warbles, burrs, and trills to attract mates and defend their territory, or scold visitors with raspy calls. Bewick's Wrens are still fairly common in much of western North America, but they have virtually disappeared from the East.

This species is named for the British engraver Thomas Bewick—a friend of John James Audubon, who collected the first recognized specimen in 1821, in Louisiana. When Audubon later saw another one, he wrote, "I refrained from killing it, in order to observe its habits. . . . It moved along the bars of the fences, with its tail generally erect, looking from the bar on which it stood toward the one next above, and caught spiders and other insects, as it ran along from one panel of the fence to another in quick succession."

Thryomanes bewickii	**ORDER** **PASSERIFORMES**	**FAMILY** **TROGLODYTIDAE / WRENS**

Cool FACT

As is true of many songbird species, a Bewick's Wren's life starts off perilously. House Wrens may eject the eggs of this relative from its nest. Both eggs and nestlings can become lunch for rat snakes and milk snakes, and domestic and feral cats go after nestlings.

Gnats do not form a significant part of the Blue-gray Gnatcatcher's diet, in spite of its name.

BLUE-GRAY GNATCATCHER

A tiny, long-tailed bird of broadleaf forests and scrublands, the Blue-gray Gnatcatcher makes itself known by its soft but insistent calls and its constant motion. It hops and sidles in the dense outer foliage of trees, foraging for insects and spiders. As it moves, this steely blue and gray bird conspicuously flicks its white-edged tail from side to side, scaring up insects and chasing after them. Mated pairs use spiderweb and lichens to build small, neat nests, which sit on top of branches and look like tree knots.

The Blue-gray Gnatcatcher's coloring and long tail—together with the way it mixes snippets of other birds' repertoires into its own high, nasal songs—have earned it the nickname little mockingbird. It is widespread but not abundant south of Canada, but, like many species, its range has been expanding northward.

Polioptila caerulea	**ORDER** **PASSERIFORMES**	**FAMILY** **POLIOPTILIDAE / GNATCATCHERS**

RUBY-CROWNED KINGLET

A tiny bird that seems to overflow with energy, the Ruby-crowned Kinglet forages almost frantically through the lower branches of shrubs and trees. Its habit of constantly flicking its wings is a key identification clue. Smaller than a warbler or chickadee, this plain green-gray bird has a white eye ring and a white bar on its wings. Alas, the male's brilliant ruby crown patch usually stays hidden—your best chance to see it is to spot an excited male singing in spring or summer. Over much of the United States, look for these kinglets in the winter or on migration, when they are widespread and quite common. During summer, you'll need to be in northern North America or the western mountains to see them.

Ruby-crowned Kinglets look nervous as they flit through the foliage, flicking their wings nearly constantly. Keeping an eye out for this habit can be helpful in identifying kinglets.

Regulus calendula	**ORDER** **PASSERIFORMES**	**FAMILY** **REGULIDAE / KINGLETS**

Cool FACT

The Ruby-crowned Kinglet is a tiny bird that lays a very large clutch of eggs—up to twelve in a single nest. Although the eggs themselves weigh only about a fiftieth of an ounce, an entire clutch can weigh as much as the female herself.

EASTERN BLUEBIRD

A summer drive in the country in eastern North America will usually turn up a few Eastern Bluebirds, sitting on telephone wires or perched atop a nest box, calling in a short, wavering voice or abruptly dropping to the ground in pursuit of an insect. Marvelous birds to capture in your binoculars, male Eastern Bluebirds are a brilliant royal blue on the back and head and warm orange on the breast. Tinges of blue on the wings and tail decorate the grayer females.

The male displays at his nest cavity to attract a female: he brings nest material to the hole, goes in and out, and waves his wings while perched above it. This is pretty much his contribution to nest building; only the female builds the nest and incubates the eggs.

Sialia sialis	ORDER **PASSERIFORMES**	FAMILY **TURDIDAE / THRUSHES & ALLIES**

Cool **FACT**

Eastern Bluebirds typically succeed in having more than one brood per year. Young produced in early nests usually leave their parents sometime in the summer, but young from later nests frequently stay with their parents over the winter.

MOUNTAIN BLUEBIRD

Male Mountain Bluebirds lend a bit of cerulean sparkle to open habitats across much of western North America. You may spot these cavity-nesters flitting between perches in mountain meadows, in burned or cut-over areas, or where prairie meets forest—especially in places where people have provided nest boxes. Unlike many thrushes, Mountain Bluebirds hunt insects from perches or while on the wing, at times resembling a tiny American Kestrel (page 182) with their long wings, hovering flight, and quick dives.

Historically, the species depended for nest sites on forest tree cavities excavated by woodpeckers. Today, many Mountain Bluebirds breed in artificial nest boxes, which are usually installed in fairly open areas and have smaller openings to keep out marauders and bad weather. Most of what we know about Mountain Bluebirds comes from studies at these human-made nesting sites.

	ORDER	FAMILY
Sialia currucoides	PASSERIFORMES	TURDIDAE / THRUSHES & ALLIES

Cool FACT A female Mountain Bluebird pays more attention to good nest sites than to attractive males. She chooses her mate solely on the basis of the location and quality of the nesting cavity he offers her—disregarding his attributes as a singer, a flier, or a thing of beauty.

HERMIT THRUSH

An unassuming-looking bird with a lovely, melancholy song, the Hermit Thrush hides in the understory of far northern forests in summer and is a frequent winter companion across much of the United States. It forages on the forest floor by rummaging through leaf litter or seizing insects with its bill. The Hermit Thrush has a rich brown upper body and smudged spots on the breast; a reddish tail sets it apart from similar species in its genus.

Hermit Thrushes usually make their nests in and around trees and shrubs, but they can also get more creative. Nests have been found on a cemetery grave, on a golf course, and in a mine shaft.

Catharus guttatus	**ORDER** PASSERIFORMES	**FAMILY** TURDIDAE / THRUSHES & ALLIES

Cool FACT

Hermit Thrushes sometimes forage by "foot quivering," in which they shake leaf litter on the ground with their feet to dislodge and uncover insects. They also typically begin to quiver their feet as they relax after seeing a flying predator. Some scientists think the quivering happens in response to a bird's conflicting impulses: resume foraging or continue taking cover?

AMERICAN ROBIN

The quintessential early bird, American Robins are common sights on lawns across North America, where you may see them tugging earthworms out of the ground. This bird's warm orange breast, cheery song, and early appearance at winter's end make it a welcome presence. Familiar to town and city dwellers, American Robins are at home in wilder areas, too, including mountain forests and Alaskan wilderness.

An American Robin can produce three broods in one year—though on average only 40 percent of nests successfully produce young, and just 25 percent of those fledged young survive to November. From that point on, about half of the robins alive in any year will make it to the next. Despite the fact that a lucky robin can live to be fourteen years old, the entire North American population turns over on average every six years.

Turdus migratorius	ORDER PASSERIFORMES	FAMILY TURDIDAE / THRUSHES & ALLIES

Cool FACT

Robins eat a lot of fruit in fall and winter. When they eat honeysuckle berries exclusively, they sometimes become intoxicated. You can plant native fruiting shrubs and trees in your yard to provide a varied menu for robins and many other birds.

Cool
FACT

The Gray Catbird's long song may
last for up to ten minutes.

GRAY CATBIRD

If you're convinced you'll never be able to learn bird calls, start with the Gray Catbird. Once you've heard its catlike *mew*, you won't forget it. Follow the sound into thickets and vine tangles and you'll be rewarded by the sight of a bird dressed in somber shades of gray with a black cap and bright rusty feathers under the tail. Related to mockingbirds and thrashers, Gray Catbirds share that group's vocal prowess, copying the sounds of other species and stringing them together to make their own song. Catbirds are found across most of North America except in the far West.

The male Gray Catbird uses his loud song to proclaim his territory and a softer version of that song when near the nest or when another bird intrudes on his territory. The female may sing the quiet song back to the male.

To attract Gray Catbirds, plant shrubs in areas of your yard near young deciduous trees. Catbirds also love fruit, so you can entice them with plantings of native fruit-bearing trees and shrubs such as dogwood, winterberry, and serviceberry.

Dumetella carolinensis	ORDER PASSERIFORMES	FAMILY MIMIDAE / MOCKINGBIRDS & THRASHERS

A polyglot (as its species name signals),
the Northern Mockingbird
continues to add new sounds to its
repertoire throughout its life.
A male may learn around two hundred
songs throughout his life.

NORTHERN MOCKINGBIRD

If you've been entertained by what sounds like ten or fifteen different birds singing outside your house, you might have a Northern Mockingbird in your yard. What they lack in bright colors, mockingbirds more than make up for in their spirited behavior and elaborate vocalizations, which include imitations of many other birds. They sing almost ceaselessly, even sometimes at night, and they flagrantly harass birds that intrude on their territories, flying slowly around them or prancing toward them with legs extended, flaunting bright white wing patches.

The Northern Mockingbird's song nearly proved its undoing. In the nineteenth century, people kept so many of them as cage birds that the species nearly vanished from parts of the East Coast. Collectors took nestlings out of nests or trapped adults and sold them; in 1828, extraordinary singers could fetch as much as fifty dollars in Philadelphia, St. Louis, or New York.

Mimus polyglottos

ORDER

PASSERIFORMES

FAMILY

MIMIDAE / MOCKINGBIRDS & THRASHERS

SPRAGUE'S PIPIT

An unassuming bird with plain buffy plumage, Sprague's Pipit's claim to fame is its amazing *musical flight display*. Hovering high above its territory on rapidly fluttering wings, it sings a lovely, downward-swirling song during bursts of gliding.

Audubon named the bird after his friend Isaac Sprague, the first to discover a pipit nest in 1843, in North Dakota. When not singing, this species is very difficult to find in its prairie and grasslands habitats, often not seen until it flushes from nearly underfoot. Because Sprague's Pipit relies on native prairie and grasslands, its populations have declined tremendously as a result of the destruction of these habitats across interior North America.

Anthus spragueii	ORDER **PASSERIFORMES**	FAMILY **MOTACILLIDAE / WAGTAILS & PIPITS**

Cool **FACT**

Displaying males often remain airborne for half an hour. In one case, a male Sprague's Pipit was observed displaying for three hours before descending to the ground. No other bird is known to perform such prolonged aerial displays.

CEDAR WAXWING

Always a treat to find in your binocular viewfield, the Cedar Waxwing is a silky, shiny collage of brown, gray, and lemon yellow, accented with a subdued crest, a rakish black mask, and brilliant red wax droplets on its wing feathers. (The birds secrete this waxy substance, whose function is uncertain; it may help attract mates.) In fall, waxwings gather by the hundreds to eat berries, filling the air with their high, thin whistles. In summer, you're likely to find them flitting about over rivers in pursuit of flying insects; for a forest bird, they're capable of dazzling aeronautics.

The Cedar Waxwing is one of the few North American birds that specializes in eating fruit. It can survive on fruit alone for several months. Brown-headed Cowbirds (page 331) raised in Cedar Waxwing nests typically don't survive, in part because cowbird chicks can't develop on such a high-fruit diet.

Bombycilla cedrorum	ORDER **PASSERIFORMES**	FAMILY **BOMBYCILLIDAE / WAXWINGS**

Cool **FACT**

In the 1960s, Cedar Waxwings with orange instead of yellow tail tips began appearing in the northeastern United States and southeastern Canada. The orange color comes from a red pigment picked up from the berries of a type of honeysuckle. If a waxwing eats enough of these berries while growing a tail feather, the feather's tip will be orange.

Cool FACT

Though these small birds look like sparrows, they belong to a different taxonomic family. The name *longspur* refers to the elongated claw of the hind toe.

CHESTNUT-COLLARED LONGSPUR

A true emblem of North America's wild and windswept spaces, the Chestnut-collared Longspur is an classic inhabitant of shortgrass prairies, rangelands, and desert grasslands. Breeding males are a bold mix of black belly, buffy throat, and the striking chestnut "collar" or nape; they flaunt these colors as they perform fluttering display flights in early summer. In winter, males and females alike are brownish and inconspicuous as they forage in desert grasslands. Despite this species' association with disturbed land, its population has declined by more than 80 percent since the 1960s.

Historically, Chestnut-collared Longspurs bred in areas grazed by bison or burned by wildfires. In modern times, they can be found in shortgrass prairies where livestock graze, as well as in other areas with very short vegetation, such as cattle pastures and mowed airstrips.

Calcarius ornatus	**ORDER** **PASSERIFORMES**	**FAMILY** **CALCARIIDAE / LONGSPURS & SNOW BUNTINGS**

BLUE-WINGED WARBLER

The Blue-winged Warbler sings a distinctive *bee-buzz* from brushy fields. This active, agile little songbird dangles from branches and leaves, foraging like a chickadee, but it shows off bright warbler plumage: a yellow belly, yellow-olive back, and white wingbars across blue-gray wings. Like most warblers, they don't visit feeders, but you might see (or more likely hear) them during their spring migration.

A specialist in shrubland and old field habitats, the Blue-winged Warbler has benefited from landscape changes over the last 150 years, as forest clear-cuts and agricultural fields have grown up into scrubby fields. These changes have helped the species expand northward, where it now hybridizes with (and possibly threatens) the much rarer Golden-winged Warbler.

Vermivora cyanoptera	**ORDER** **PASSERIFORMES**	**FAMILY** **PARULIDAE / NEW WORLD WARBLERS**

Cool FACT

The oldest recorded Blue-winged Warbler was a male, at least nine years old when it was recaptured and re-released during banding operations in New Jersey.

For Prothonotary Warblers, it pays to be bright. According to a study conducted in Louisiana, males that are brighter yellow gain access to better nest sites than less colorful males.

PROTHONOTARY WARBLER

The brilliant Prothonotary Warbler bounces along branches in the dim understory of swampy woodlands. This golden ray of light, with beady black eyes and blue-gray wings, is one of only two warblers that build nests in holes in standing dead trees. Often called a "swamp warbler" in the Southeast, it also occurs surprisingly far north along rivers. Its population is declining due to loss of forested wetlands in the United States and mangroves on its wintering grounds.

The name of the Prothonotary Warbler derives from the chief clerk (or notary) of the English court system: the official robe for this job includes a saffron yellow cowl similar to the warbler's color. This species became famous during the Cold War. In 1948, the government official Alger Hiss was accused of being a Soviet spy. Part of the trial hinged on whether Hiss knew Whittaker Chambers, a former Communist Party member. Chambers claimed that he talked to Hiss about birds and reported Hiss's excitement at seeing a Prothonotary Warbler on the Potomac River. This sighting linked the two men, eventually leading to Hiss's conviction as well as to Richard Nixon's rise to political power.

Protonotaria citrea	**ORDER** PASSERIFORMES	**FAMILY** PARULIDAE / NEW WORLD WARBLERS

COMMON YELLOWTHROAT

A broad black mask lends a touch of the highwayman's mystique to the male Common Yellowthroat. Look for these yellow and olive warblers skulking through tangled vegetation, often at the edges of marshes and wetlands. Females lack the mask and are much browner, though they usually show a hint of warm yellow at the throat. Yellowthroats are vocal birds: their *witchety-witchety-witchety* song and distinctive call notes help reveal the presence of this warbler, one of our most numerous.

In another case of brood parasitism, Brown-headed Cowbirds often lay their eggs in the nests of Common Yellowthroats (and many other songbird species). It's detrimental to the yellowthroats, so they've developed a few defenses. They desert a nest if it contains a cowbird egg, or if their own eggs have been removed or damaged by a visiting cowbird. They may build a second or even a third nest on top of a parasitized nest.

Geothlypis trichas	ORDER PASSERIFORMES	FAMILY PARULIDAE / NEW WORLD WARBLERS

Cool FACT

The Common Yellowthroat was one of the first New World bird species to be cataloged, when Carl Linnaeus in 1766 described a specimen from Maryland.

HOODED WARBLER

The Hooded Warbler flits through the shrubby understory of eastern forests, which can make it easier to find than the canopy-dwelling warblers. It shows off white tail feathers with every tail flick, and the male's charmingly marked face also draws your attention: bright yellow cheeks and forehead outlined by a black hood and throat. Females lack the bold black hood, but their yellow cheeks still stand out. Listen for this bird's characteristic song on its breeding grounds in the East and its metallic *chip* on wintering grounds in Mexico and Central America.

Both male and female Hooded Warblers are strongly territorial on their wintering grounds, despite birds of each sex using a different habitat at this time. Males are found in mature forest and females in scrubbier forest and seasonally flooded areas.

Setophaga citrina	ORDER **PASSERIFORMES**	FAMILY **PARULIDAE / NEW WORLD WARBLERS**

Cool FACT

The white spots on a Hooded Warbler's tail help them capture more insects, possibly by startling the insects into taking flight. A study conducted in Pennsylvania found that birds with temporarily darkened tail feathers were less successful at capturing insects than those with white spots on their tails.

AMERICAN REDSTART

A lively warbler that hops among tree branches in search of insects, the male American Redstart is coal black with vivid orange patches on the sides, wings, and tail. In keeping with its Halloween-themed color scheme, this redstart seems to startle its prey out of the foliage by flashing its strikingly patterned tail and wing feathers. The name *redstart* derives partly from the Dutch word *staart*, meaning "tail," and refers originally to small Old World flycatchers such as the Black Redstart, which has a rusty tail. When the first European settlers saw American Redstarts, they gave them the name of the most similar bird in their experiences from their native land. Females and immature males have more subdued yellow *flash patterns* on a gray background.

These sweet-singing warblers nest in open woodlands across much of North America.

Setophaga ruticilla	**ORDER** **PASSERIFORMES**	**FAMILY** **PARULIDAE / NEW WORLD WARBLERS**

Cool FACT

The male American Redstart sometimes has two mates at the same time, keeping them at a distance in territories that can be separated by a quarter mile.

CERULEAN WARBLER

A warbler the color of a clear blue sky lives sky high, in the upper canopy of eastern forests. That's the male Cerulean Warbler, a brilliant blue songbird with a neck band, white wingbars, and darker streaks down its sides. Females are equally well dressed, wearing a subtler shade of blue-green. These long-distance migrants breed in mature eastern deciduous forests and spend the winters in the Andes in South America. Their numbers have declined dramatically due to habitat loss.

On their wintering grounds in South America, Cerulean Warblers are usually found in mixed-species canopy flocks, associating with tropical tanagers and other resident species.

Setophaga cerulea	ORDER **PASSERIFORMES**	FAMILY **PARULIDAE / NEW WORLD WARBLERS**

Cool **FACT**

The female Cerulean Warbler has an unusual way of decamping after sitting on a nest for a while. In what's sometimes called "bungee jumping," she drops from the side of the nest with her wings folded, opening them to fly only when she is well below the nest.

YELLOW-RUMPED WARBLER

Yellow-rumped Warblers flood the continent in impressive numbers when they migrate each fall. Shrubs and trees fill with the streaky, brown-and-yellow birds, and the air is filled with their distinctive, sharp *chips*. Although the bird's color palette is subdued all winter, the spring molt transforms their coloring into a dazzling mix of bright yellow, bluish gray, black, and bold white. You owe it to yourself to seek these birds out on their spring migration or on their northerly breeding grounds.

The Yellow-rumped may be the most versatile foragers of all warblers. It's the warbler you're most likely to see fluttering from a tree to catch a flying insect, and they're quick to switch over to eating berries in fall. Yellow-rumped Warblers have been spotted pecking at insects on seaweed washed up on beaches, skimming insects from the surface of rivers and oceans, and plucking them out of spiderwebs or off piles of manure.

Setophaga coronata	ORDER **PASSERIFORMES**	FAMILY **PARULIDAE / NEW WORLD WARBLERS**

Cool FACT

The Yellow-rumped Warbler is the only warbler able to digest the waxes found in bayberries and wax myrtles. Its ability to feed on these fruits allows it to winter farther north than other warblers, sometimes as far north as Newfoundland.

PAINTED REDSTART

Black and white above with a bright red belly, the Painted Redstart is a large warbler of surpassing beauty, native to the borderlands of the American Southwest. The only member of its genus that regularly occurs in the United States, it is unique among American warblers for its vocalizations and its conspicuous foraging methods.

Like other redstarts in its genus, the Painted Redstart flashes its white wing patches and outer tail feathers when foraging. These actions appear to flush insects, which the redstart then pursues and captures.

Myioborus pictus	**ORDER** **PASSERIFORMES**	**FAMILY** **PARULIDAE / NEW WORLD WARBLERS**

Cool FACT

Despite its common name, the Painted Redstart is not closely related to the American Redstart. Members of its genus, common in the Neotropics, are sometimes known as whitestarts to distinguish them. The name *redstart* was borrowed from a European flycatcher that has a bold reddish tail pattern.

YELLOW-BREASTED CHAT

The Yellow-breasted Chat unleashes a cascade of song in the spring, males delivering streams of whistles, cackles, chuckles, and gurgles with the fluidity of improvisational jazz. They're seldom seen or heard during the rest of the year, when both males and females move around silently in the shadows of dense thickets, gleaning insects and berries for food. The largest of our warblers, the chat is a widespread breeder in shrubby habitats across North America, venturing to Central America for the winter.

The Yellow-breasted Chat has traditionally been placed in the family of New World warblers, although it is an unusual one: larger than other warblers, it has a more varied repertoire of songs and calls and also differs in certain aspects of behavior and anatomy. In 2018, American ornithologists voted to give the chat its own family, Icteriidae, of which it is the only member. They think its closest relatives might be the blackbirds, in family Icteridae, but research continues.

Icteria virens	**ORDER** **PASSERIFORMES**	**FAMILY** **ICTERIIDAE / YELLOW-BREASTED CHAT**

Cool **FACT**

Though a small percentage of male chats have two mates at once, most appear to be monogamous during the breeding season. Female aggression may help enforce this monogamy. However, some infidelity happens behind the scenes: in a Kentucky study, a third of nests contained at least one chick sired by a male not linked to that nest.

CASSIN'S SPARROW

A grayish brown sparrow with a hint of an eye ring, the Cassin's Sparrow makes up for in musical performance what it lacks in bright colors. Breeding males sing a whistled melody while fluttering in midair above their territories, twenty feet high or more. Ornithologist Henry Wetherbee Henshaw wrote that the song had an "indescribable sweetness and pathos." These fairly large sparrows live in the dry grasslands of the southern Great Plains, southwestern United States, and northern Mexico, often moving around to take temporary advantage of good conditions after rainfall.

In April 1851, Samuel Washington Woodhouse, a surgeon and natural historian, collected the first Cassin's Sparrow described to science, a male, near San Antonio, Texas. He named it after his friend John Cassin, curator of birds at the Academy of Natural Sciences in Philadelphia.

Peucaea cassinii	**ORDER** **PASSERIFORMES**	**FAMILY** **PASSERELLIDAE / NEW WORLD SPARROWS**

Cool **FACT**

In his display flight, the male Cassin's Sparrow flies straight up and then floats downward on fixed wings, singing the entire time. This kind of display is unusual in sparrows but fairly common in larks; in fact, it is often called "skylarking."

GRASSHOPPER SPARROW

The stubby-tailed and bull-necked Grasshopper Sparrow is easy to overlook throughout its range. When not singing its quiet, insectlike song from atop a stalk in a weedy pasture, it disappears into the grasses. Rather than flying, it usually runs along the ground. They also nest on the ground, in a domed nest typically hidden at the base of a grass clump. As sparrows go, these birds are lightly marked: buffy tan with clean, unstreaked underparts contrasting with brown, gray, and traces of orange above. The flat head, which bears an almost comically large bill for such a small bird, completes the distinctive look.

The Grasshopper Sparrow is one of the few North American sparrows that sings two different songs. The more common song is a dry insectlike buzz, but males in flight also sound a more musical series of squeaky notes.

Ammodramus savannarum	ORDER **PASSERIFORMES**	FAMILY **PASSERELLIDAE / NEW WORLD SPARROWS**

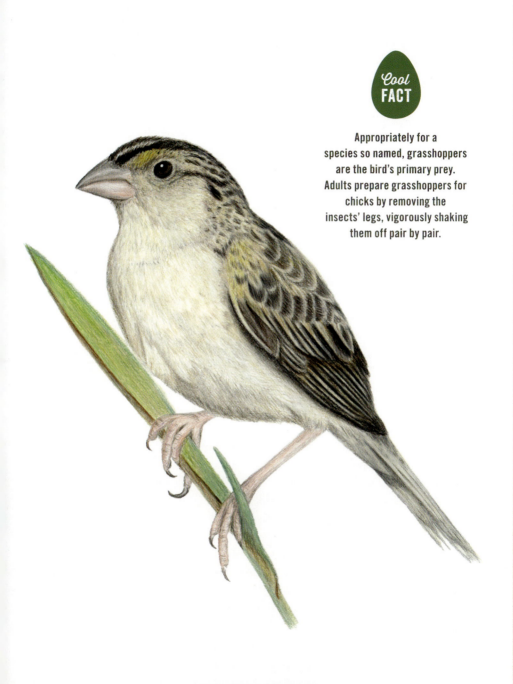

Cool FACT

Appropriately for a species so named, grasshoppers are the bird's primary prey. Adults prepare grasshoppers for chicks by removing the insects' legs, vigorously shaking them off pair by pair.

BAIRD'S SPARROW

The clear, tinkling song of the Baird's Sparrow is a defining sound of the northern Great Plains. Once among the most common birds of the tallgrass prairie, this species is a casualty of habitat alteration and the loss of native grassland to agriculture. Colored a warm yellowish brown, with neat black and chestnut streaks, this sparrow spends most of its time on the ground, foraging for insects and seeds. Some 65 percent of its population has disappeared since 1968, putting it on the Yellow Watch List for declining species.

Baird's Sparrow has the distinction of being the last "new" bird described by Audubon, who first collected the species in 1843 in North Dakota. A specimen was not recorded again for another twenty-nine years.

Centronyx bairdii	**ORDER** PASSERIFORMES	**FAMILY** PASSERELLIDAE / NEW WORLD SPARROWS

Cool FACT

Baird's Sparrows often escape predators (and birdwatchers) by running on the ground rather than taking flight.

CHIPPING SPARROW

A pretty, crisply patterned sparrow, whose bright rufous cap provides a splash of color and makes adults fairly easy to identify, Chipping Sparrows are common across North America wherever trees are interspersed with grassy openings. Their loud, trilling song is among the most common sounds of spring woodlands and suburbs. Especially in fall and winter, watch for small flocks of Chipping Sparrows feeding on open ground near trees. If a feeder hangs above, they're even more likely to visit.

The early naturalists had a gift for description. In 1929, Edward Forbush called the Chipping Sparrow "the little brown-capped pensioner of the dooryard and lawn, that comes about farmhouse doors to glean crumbs shaken from the tablecloth by thrifty housewives."

Spizella passerina	**ORDER** **PASSERIFORMES**	**FAMILY** PASSERELLIDAE / NEW WORLD SPARROWS

Cool **FACT**

The nest of the Chipping Sparrow is of such flimsy construction that light can be seen through it. It probably provides little insulation for the eggs and young.

DARK-EYED JUNCO

Dark-eyed Juncos are neat, even flashy little sparrows that flit about boreal forests and mountains in the United States and Canada, then flood the rest of North America for winter. They're easy to recognize by their crisp (though extremely variable) markings and the bright white tail feathers they habitually flash in flight. One of the most abundant forest birds of North America, juncos can be seen on woodland walks, in flocks at your feeders, or on the ground beneath them.

Juncos are classic "snowbirds" of the middle latitudes. Over most of the East, they appear as winter sets in, and then retreat northward each spring. Other juncos are year-round residents, retreating into woodlands during the breeding season or, like those of the Appalachian Mountains, moving to higher elevations during the warmer months.

Junco hyemalis	**ORDER** PASSERIFORMES	**FAMILY** PASSERELLIDAE / NEW WORLD SPARROWS

Cool **FACT**

The Dark-eyed Junco is one of the most common birds on the continent, found from Alaska to Mexico and from California to New York. A recent estimate set the junco's total population at approximately 630 million individuals.

WHITE-CROWNED SPARROW

White-crowned Sparrows appear each winter over much of North America to grace our gardens and favorite trails (they live in parts of the West year-round). The slightly peaked, black-and-white head, pale beak, and gray breast combine for a dashing look—and make its identification one of the surest among North American sparrows. Watch for flocks of these sparrows scurrying through brushy borders and overgrown fields, or coax them into the open with backyard feeders. As spring approaches, listen for this bird's thin, sweet whistle.

During the first two or three months of its life, a young male White-crowned Sparrow learns the basics of the song it will sing as an adult. It does not learn directly from its father but rather from the generalized song environment of its natal neighborhood.

Zonotrichia leucophrys	**ORDER** PASSERIFORMES	**FAMILY** PASSERELLIDAE / NEW WORLD SPARROWS

Cool **FACT**

Scientists interested in movement and energetics have discovered that White-crowned Sparrows can run on a treadmill at a pace of about 0.33 miles an hour without tiring out.

SAVANNAH SPARROW

Streaky brown birds are notoriously hard to identify. But take a closer look at this one, and you'll see an understated but distinctive sparrow with a short tail, a small head, and a telltale yellow spot between eye and beak. Savannah Sparrows are among the most numerous songbirds in North America, likely visitors to open habitats all across the continent. They tend to return each year to the place where they were hatched, a trait that has contributed to a proliferation of subspecies. In summer, they don't hesitate to advertise their location, belting out a loud, insectlike song from farm fields and grasslands.

The Savannah Sparrow's name sounds like a nod to its fondness for grassy areas, but this species was actually named by the famed nineteenth-century ornithologist Alexander Wilson for a specimen collected in Savannah, Georgia.

Passerculus sandwichensis	**ORDER** **PASSERIFORMES**	**FAMILY** **PASSERELLIDAE / NEW WORLD SPARROWS**

Cool **FACT**

Raising young is hard work: a female Savannah Sparrow must gather ten times her weight in food to feed herself and her young during the eight to twelve days they spend in the nest.

SONG SPARROW

Colored a rich russet and gray with bold streaks down its white chest, the Song Sparrow is one of the most familiar North American sparrows. Don't be deterred by the bewildering variety of regional differences this bird shows across North America: it's perhaps the first species you should suspect if you see a streaky sparrow in an open, shrubby, or wet area. If the sparrow perches on a low shrub, leans back, and sings a stuttering, clattering song, so much the better for identifying it.

Song Sparrows seem to have a clear idea of what makes a good nest. Field researchers working for many years on the same parcels of land have noticed that these birds use certain choice spots—the base of a rosebush, for example, or a particular hollow under a hummock of grass—over and over again, even when new individuals take over the territory.

Melospiza melodia	ORDER PASSERIFORMES	FAMILY PASSERELLIDAE / NEW WORLD SPARROWS

Cool FACT

Some scientists think that the darker plumage seen on Song Sparrows of wet, coastal areas is a defense against feather mites and other feather-damaging creatures, such as *Bacillus* bacteria, which especially thrive in humid climates. The darker plumage contains more of the pigment melanin, which makes feathers tougher and harder to degrade than lighter, less-pigmented feathers.

LINCOLN'S SPARROW

The dainty Lincoln's Sparrow has a talent for concealing itself. It sneaks around the ground amid willow thickets in wet meadows, rarely straying from cover. When it decides to pop up and sing from a willow twig, its sweet, jumbling song sounds more like that of a wren than a sparrow. Its plumage, on the other hand, is all sparrow: attired in shades of brown and tan with delicate streaking down its chest and sides and a buffy "mustache."

A beautiful song might not be enough to win over a female. In a laboratory study, female Lincoln's Sparrows were more attracted to males that sang on colder mornings than to those singing during warmer mornings. Singing in the cold requires more energy, so researchers speculated that those males might make better mates.

Melospiza lincolnii	ORDER **PASSERIFORMES**	FAMILY **PASSERELLIDAE / NEW WORLD SPARROWS**

Cool FACT

Although they breed only in the far North, Lincoln's Sparrows then scatter all over North America in their preferred shrubby habitats. The species shows less geographical variation in its song than any other species in its genus, perhaps a result of high dispersal rates among juveniles.

SPOTTED TOWHEE

The Spotted Towhee is a large, striking sparrow of sunbaked thickets of the West. These handsome birds are gleaming black above (females are grayish brown), spotted and striped with brilliant white. Their warm rufous flanks match the dry leaves they spend their time hopping around in. The birds can be hard to see in the leaf litter, so your best chance for an unobstructed look may be in the spring, when males climb into the shrub tops to sing their buzzy songs. The very similar-looking (except for the spots) Eastern Towhee was once combined in with this species under the name Rufous-sided Towhee.

Watch a towhee feeding on the ground; you'll probably observe its two-footed, backward-scratching hop. This "double scratching" is used by several towhee and sparrow species to uncover the seeds and small invertebrates they feed on. One Spotted Towhee with an injured and unusable foot was observed hopping and scratching with one foot.

Pipilo maculatus

ORDER

PASSERIFORMES

FAMILY

PASSERELLIDAE / NEW WORLD SPARROWS

Early in the breeding season, male Spotted Towhees spend their mornings singing their hearts out, trying to attract a mate. Male towhees have been recorded spending 70 to 90 percent of their mornings singing. Almost as soon as they attract a mate, their attention shifts to other things, and the percentage drops to 5 percent.

WESTERN TANAGER

A rare clear glimpse of a male Western Tanager is like looking at a flame: the bird has an orange-red head, a brilliant yellow body, and coal black wings, back, and tail. Females and immature birds are a somewhat dimmer yellow-green and blackish. Quintessential denizens of woodlands, Western Tanagers live in open woods all over the West, particularly among evergreens, where they often stay hidden in the canopy. In summertime, they fill the woods with their short, burry song and low, staccato call notes.

Whereas most red birds owe their color to plant pigments known as carotenoids, the Western Tanager gets its scarlet head feathers from a rare pigment called rhodoxanthin. Unable to make this substance in their own bodies, Western Tanagers probably obtain it from insects in their diet.

Piranga ludoviciana	**ORDER** **PASSERIFORMES**	**FAMILY** **CARDINALIDAE / CARDINALS & ALLIES**

Cool **FACT**

Male Western Tanagers sometimes perform an antic, eye-catching display—possibly a courtship ritual—in which they tumble past a female, their showy plumage flashing yellow and black.

NORTHERN CARDINAL

Perhaps more than any other bird, the male Northern Cardinal is responsible for getting people to open up a field guide. He is all a birdwatcher could want: familiar, conspicuous, and stylish, dressed in a shade of red you can't take your eyes off. Even the olive-brown females sport a sharp crest and warm red accents. Cardinals don't migrate or molt into a dull plumage, so they're all the more breathtaking in snowy backyards. In summer, their sweet whistle is one of the first sounds of the morning.

People are often perplexed by the springtime sight of a cardinal attacking its reflection in a window, car mirror, or shiny bumper. Both males and females do this—sometimes for hours and most often in spring and early summer, when they are obsessed with defending their territory against any intruder. Such attacks usually end a few weeks later, as levels of aggression hormones subside, though one female kept up the behavior every day or so for six months without stopping.

Cardinalis cardinalis	**ORDER** PASSERIFORMES	**FAMILY** CARDINALIDAE / CARDINALS & ALLIES

Cool FACT

A perennial favorite across the United States, the Northern Cardinal is the state bird of seven states.

ROSE-BREASTED GROSBEAK

Dazzling in black, white, and rose red, male Rose-breasted Grosbeaks make an exclamation mark at your bird feeder or in your binoculars. Females and immature birds are streaked brown and white with a bold face pattern and (like the male) an enormous bill. Look for these birds in forest edges and woodlands and listen for their distinctive voice. They sound like American Robins, but you'll hear an extra sweetness; they also make a sharp *chink* like the squeak of a sneaker.

This bird's robinlike song has inspired many an observer to pay tribute. A couple of early-twentieth-century naturalists said that it is "so entrancingly beautiful that words cannot describe it," going on to note that "it has been compared with the finest efforts of the robin and . . . the Scarlet Tanager, but it is far superior to either." Present-day birdwatchers have variously suggested that the grosbeak sings like a robin that has had opera training, or one that is drunk, refined, in a hurry, or unusually happy.

Pheucticus ludovicianus	**ORDER** **PASSERIFORMES**	FAMILY **CARDINALIDAE / CARDINALS & ALLIES**

Cool **FACT**

The male Rose-breasted Grosbeak takes a turn incubating the eggs for several hours during the day; the female incubates for the rest of the day and all night long. Both sexes sing quietly to each other when they exchange places. The male sometimes sings his normal song at full volume from inside the nest.

BLUE GROSBEAK

A large, vibrantly blue bunting with an enormous silver bill and chestnut wingbars, the male Blue Grosbeak sings a rich, warbling song from trees and roadside wires. He and his cinnamon-colored mate often raise two broods of nestlings in a single breeding season. A bird of shrubby habitats, this grosbeak can be hard to spot unless you hear it singing first. It is widespread but not abundant across the southern United States, and its range is expanding.

Many Blue Grosbeaks migrate directly southward from breeding areas to their wintering grounds without stopping. Western birds travel over land, and eastern birds cross the Gulf of Mexico. Migrating grosbeaks also pass through the Caribbean Islands, including Puerto Rico, the Bahamas, the Turks and Caicos Islands, the Antilles, the Swan Islands, the Cayman Islands, and the Virgin Islands.

Passerina caerulea	**ORDER** **PASSERIFORMES**	**FAMILY** **CARDINALIDAE / CARDINALS & ALLIES**

Cool **FACT**

Blue Grosbeaks breed along
roads and open areas, building their nests
low to the ground in small trees,
shrubs, tangles of vines, or briars. At least
one pair of grosbeaks has nested in
a bluebird nest box.

LAZULI BUNTING

The male Lazuli Bunting lights up dry, brushy hillsides, thickets, and gardens throughout the West, flashing the blue of a lapis gemstone mixed with splashes of orange. He belts out his squeaky and jumbling song from atop shrubs to attract a mate and defend his territory. The softly colored female is often nearby, balancing precariously on tiny stems to reach seeds and other fare. This stocky, finchlike bird is related to cardinals and grosbeaks and often visits bird feeders, especially those filled with millet.

We recognize people by their voices, and Lazuli Buntings may, too. Young males hear and imitate older males, creating a kind of "song neighborhood," within which songs sung by all of them sound similar. Males of that neighborhood learn to recognize and tolerate each other. They respond more aggressively to unfamiliar songs coming from outside their neighborhood.

Passerina amoena	**ORDER** **PASSERIFORMES**	**FAMILY** **CARDINALIDAE / CARDINALS & ALLIES**

Cool **FACT**

The beauty of the Lazuli Bunting did not escape the early naturalist who named it *Passerina amoena*, meaning "beautiful sparrow."

INDIGO BUNTING

The blue-all-over male Indigo Bunting looks like a scrap of sky with wings and sings with cheerful gusto. Nicknamed blue canaries, these brilliantly colored birds whistle their bouncy songs through the late spring and summer all over eastern North America. They are common and widespread: look for Indigo Buntings in weedy fields and shrubby areas near trees, singing from dawn to dusk atop the tallest perch in sight or foraging for seeds and insects in low vegetation.

Indigo Buntings migrate at night, using the stars for guidance. Researchers in the late 1960s demonstrated this process by studying captive Indigo Buntings in a planetarium and then under the night sky. The birds possess an instinctive navigational sense that enables them to continually adjust their angle of orientation to a star, even as that star moves through the night sky.

Passerina cyanea	ORDER **PASSERIFORMES**	FAMILY **CARDINALIDAE / CARDINALS & ALLIES**

Cool FACT

Like all other blue birds, Indigo Buntings lack blue pigment. Their jewel-like color comes instead from microscopic structures in the feathers that refract and reflect blue light, much like the airborne particles that cause the sky to look blue.

PAINTED BUNTING

A vivid fusion of blue, green, yellow, and red, the male Painted Bunting seems to have flown straight out of a child's coloring book. Females and immatures are a distinctive bright green with a pale eye ring. These fairly common songbirds breed in the coastal Southeast and in the south-central United States, where they readily come to feeders.

In 1841, Audubon reported that "thousands" of Painted Buntings were caught every spring and shipped from New Orleans to Europe, where they fetched astounding prices as cage birds. Even today, they are often caught and sold illegally as cage birds—particularly in Mexico, Central America, the Caribbean, and to a lesser extent in Florida—a practice that puts pressure on their breeding populations. Conservationists campaign to curb the illegal trade.

Passerina ciris	**ORDER** **PASSERIFORMES**	**FAMILY** **CARDINALIDAE / CARDINALS & ALLIES**

Cool
FACT

The French name of the Painted Bunting, *nonpareil*, means "without equal," a reference to the bird's dazzling plumage.

DICKCISSEL

Part of the soundtrack of the North American prairies, the curt song of the Dickcissel sounds like the bird's name. It's hard to miss, a clicky, buzzing *dick-dick-ciss-ciss-el*. This chunky grassland bunting is colored like a miniature meadowlark, with a black V on a yellow chest. They are erratic wanderers—common across the middle of the continent and a pleasant surprise whenever they turn up in pastures and fields in the central and eastern United States.

Dickcissels can form enormous flocks during migration and in winter. In preparation for the fall migration, Dickcissels assemble into flocks that can reach into the thousands. On their Neotropical wintering grounds, flocks can be even larger, numbering in the millions of birds.

Spiza americana	**ORDER** **PASSERIFORMES**	**FAMILY** **CARDINALIDAE / CARDINALS & ALLIES**

Cool FACT

While the Dickcissel is currently classified as part of the cardinal family (Cardinalidae), it has vexed taxonomists trying to determine its closest relatives. In the past, it has been placed in the family of New World sparrows but at other times in the oriole and blackbird family.

BOBOLINK

Perched on a grass stem or displaying in flight over a field, breeding male Bobolinks are striking. No other North American bird has a white back and black underparts—a look some have described as wearing a tuxedo backward—and for a bonus, a contrasting straw-colored patch on the back of his head. As summer ends, he molts into a buff and brown, femalelike plumage. The Bobolink's bubbling, virtuosic song is punctuated with sharp, metallic *pinks*, the source of its common name. Though they're still fairly common in grasslands, the species' numbers are declining.

A migrating Bobolink can orient itself with the earth's magnetic field, thanks to iron oxide in the bristles of its nasal cavity and in tissues around the olfactory bulb and nerve. Bobolinks also use the starry night sky to guide their travels.

Dolichonyx oryzivorus	**ORDER** **PASSERIFORMES**	**FAMILY** **ICTERIDAE / TROUPIALS & ALLIES**

Cool **FACT**

The Bobolink was immortalized by nineteenth-century American poet William Cullen Bryant, in a poem titled "Robert of Lincoln." The poem recounts the events of "Bob-o'-Link's" nesting season, describing the male's flashy coat and song, the female's modest attire and subdued voice, and the six purple-flecked eggs that hatch into nestlings.

RED-WINGED BLACKBIRD

One of the most abundant birds across North America and one of the most memorably marked, the Red-winged Blackbird is a familiar sight atop cattails, along soggy roadsides, and on telephone wires. Glossy black males have scarlet and yellow wing patches they can puff up or hide, by covering these patches with their shoulder feathers (scapulars). Females are a subdued, streaky brown, almost like a large, dark sparrow. This bird's tumbling song is an early and happy sign of spring's return.

Different populations and subspecies of Red-winged Blackbirds vary markedly in size and proportions. One experiment moved nestlings between populations, finding that the chicks grew up to resemble their foster parents. This study indicated that the differences seen between populations are largely the result of different environments rather than different genetics.

Agelaius phoeniceus	**ORDER** **PASSERIFORMES**	**FAMILY** **ICTERIDAE / TROUPIALS & ALLIES**

Cool FACT

The Red-winged Blackbird is a strongly *polygynous* species, meaning that males have many female mates—up to fifteen in some cases.

WESTERN MEADOWLARK

The buoyant, flutelike melody of the Western Meadowlark, ringing out across a field, can brighten anyone's day. Meadowlarks are often more easily heard than seen, unless you spot a male singing from a fence post. This colorful, long-billed member of the blackbird family flashes a vibrant yellow breast spanned by a distinctive, black, V-shaped band. Look and listen for these stout ground feeders in grasslands, meadows, pastures, and along marsh edges throughout the West and Midwest, where flocks strut and feed on seeds and insects.

Audubon gave the Western Meadowlark its scientific name, *Sturnella* (meaning "starlinglike" or "little starling") *neglecta*, claiming that most explorers and settlers who ventured west of the Mississippi after Lewis and Clark had overlooked this common bird.

Sturnella neglecta	ORDER **PASSERIFORMES**	FAMILY **ICTERIDAE / TROUPIALS & ALLIES**

Cool FACT

The Western Meadowlark is the state bird of six states: Kansas, Montana, Nebraska, North Dakota, Oregon, and Wyoming. Only the Northern Cardinal is a more popular civic symbol, edging out the meadowlark by one state.

YELLOW-HEADED BLACKBIRD

With a golden head, a white patch on black wings, and a call that sounds like a rusty farm gate opening, the Yellow-headed Blackbird demands your attention. Look for them in western and prairie wetlands, where they nest in reeds directly over the water. They're just as impressive in winter, when huge flocks seem to roll across farm fields. Each bird gleans seeds from the ground, then leapfrogs over its flockmates to the front edge of the ever-advancing troop.

The male Yellow-headed Blackbird defends a small territory of prime nesting reeds. He may attract up to eight females to nest within his area. The male helps feed nestlings—but usually in only the first nest established in his territory; the other females are on their own at feeding time.

Xanthocephalus xanthocephalus	ORDER **PASSERIFORMES**	FAMILY **ICTERIDAE / TROUPIALS & ALLIES**

Cool **FACT**

Because Yellow-headed Blackbirds always build their nests over water, nestlings sometimes fall in and must swim short distances to vegetation.

BREWER'S BLACKBIRD

The male Brewer's Blackbird is best seen in full sun to properly appreciate his glossy, almost liquid-looking plumage of black, midnight blue, and metallic green. Females are a staid brown, lacking the male's bright eye or the streaking found on female Red-winged Blackbirds. These long-legged, ground-foraging birds are common in towns and open habitats of much of the West—you'll see them on sidewalks and in city parks and hear them chattering in flocks atop shrubs, trees, and reeds.

Brewer's Blackbirds are social, nesting in colonies of up to a hundred birds. The first females to arrive choose a nest site they like, and later arrivals follow suit. The eggs are extremely variable in color and pattern. Studies suggest that this variability helps the eggs match the background pattern of the nest, helping to camouflage them.

Euphagus cyanocephalus	ORDER PASSERIFORMES	FAMILY ICTERIDAE / TROUPIALS & ALLIES

Cool FACT

Most birds fly south for the winter, but a small number of Brewer's Blackbirds fly west—leaving the frigid Canadian prairies for the milder coastal regions of British Columbia and Washington.

Cool
FACT

Common Grackles are resourceful foragers. They have been known to follow plows to catch invertebrates and mice, wade into water to nab small fish, pick leeches off the legs of turtles, steal worms from American Robins, raid nests, and kill and eat adult birds.

COMMON GRACKLE

The Common Grackle is a blackbird that looks like it's been slightly stretched. Taller and longer-tailed than a typical blackbird, it has a longer, more tapered bill and a glossy, iridescent body. Grackles stalk around lawns and fields on their long legs or gather in noisy groups high in trees, typically evergreens. They are frequent but usually unpopular guests at feeders, and they eat many crops (notably corn) and nearly anything else as well, including garbage. In flight, their long tails trail behind them, sometimes folded down the middle into a shallow V shape.

Even though the raggedy figures placed in cornfields are called scare*crows*, the number-one threat to corn is grackles. They eat ripening ears as well as corn sprouts, and their habit of foraging in big flocks makes a multimillion-dollar impact. Some farmers try to reduce this by spraying a foul-tasting chemical on corn sprouts or by culling grackles at their roosts.

Quiscalus quiscula

ORDER

PASSERIFORMES

FAMILY

ICTERIDAE / TROUPIALS & ALLIES

BRONZED COWBIRD

A compact, bull-necked bird of open country, the Bronzed Cowbird forages for seeds and grains on the ground, usually in flocks. In good light, the male shimmers: he is a deep, glossy blue on the wing, and his black body has a velvety bronze sheen. Both males and females have intense red eyes. Like its smaller relative, the Brown-headed Cowbird, this unusual bird is a brood parasite—it lays eggs (sometimes lots of them) in other birds' nests, leaving the hosts to provide all the care for its young, usually to the detriment of the host birds' own offspring.

In recent years, both Brown-headed and the more southerly-living Bronzed Cowbirds have expanded their ranges, and the two species now overlap extensively. Competition for host nests has been one result. The Bronzed Cowbird tends to lay eggs in the nests of larger species than the Brown-headed does—but host nests containing the eggs of both cowbird species are often reported.

Molothrus aeneus	ORDER **PASSERIFORMES**	FAMILY **ICTERIDAE / TROUPIALS & ALLIES**

Cool **FACT**

The record for the number of Bronzed Cowbird eggs found in a single nest is seventeen.

BROWN-HEADED COWBIRD

The Brown-headed Cowbird is a stocky blackbird with a fascinating approach to raising its young. It is North America's most common brood parasite: females forgo building nests and instead put all their energy into producing eggs, sometimes more than three dozen a summer. These they lay in the nests of other birds, abandoning their young to foster parents—usually at the expense of at least some of the host's own chicks. Once confined to the open grasslands of middle North America, cowbirds have surged in numbers and range as humans built towns and cleared woods.

Look for Brown-headed Cowbirds in fields, meadows, and lawns. During winter and migration, search through mixed-species blackbird flocks for the glossy black plumage and subtle brown head in males; females are unmarked brown. You may also hear the male's gurgling song and the female's chatter call.

Molothrus ater	ORDER **PASSERIFORMES**	FAMILY **ICTERIDAE / TROUPIALS & ALLIES**

Cool FACT

Brown-headed Cowbirds lay eggs in the nests of more than 220 species of birds. Recent genetic analyses have shown that most individual females specialize in one particular host species.

BALTIMORE ORIOLE

The complex, whistling song of the Baltimore Oriole, issuing from treetops near homes and parks, is a sweet herald of spring in eastern North America. Look way up to find these singers: the male's brilliant orange plumage blazes from high branches like a torch. Nearby, you might spot the female weaving her remarkable hanging nest from slender fibers. Fond of fruit and nectar as well as insects, Baltimore Orioles are easily lured to backyard feeders.

Unlike robins and many other fruit-eating birds, Baltimore Orioles seem to prefer ripe, dark-colored fruit. Orioles seek out the darkest mulberries, the reddest cherries, and the deepest-purple grapes and will ignore green grapes and yellow cherries even if ripe.

Icterus galbula	**ORDER** PASSERIFORMES	**FAMILY** ICTERIDAE / TROUPIALS & ALLIES

Cool FACT

Baltimore Orioles (and their namesake baseball team) got their name from their bold orange and black plumage: the colors derive from the heraldic crest of England's Baltimore family, who also gave their name to Maryland's largest city.

HOUSE FINCH

Originally a bird of the western United States and Mexico, the House Finch is a recent introduction into eastern North America (and Hawaii), but it has received a warmer reception than other interlopers like the European Starling and House Sparrow. That's partly due to the male's cheerful red head and breast and to the bird's long, twittering song, which can now be heard in most of the neighborhoods across the continent. If you haven't seen this bird, chances are that one will show up at a bird feeder near you sooner or later.

In 1940, a small number of these finches were turned loose on Long Island, New York, after failed attempts to sell them as cage birds ("Hollywood finches"). They quickly started breeding and within the next fifty years spread across almost all of the eastern United States and southern Canada.

Haemorhous mexicanus	ORDER PASSERIFORMES	FAMILY FRINGILLIDAE / FINCHES, EUPHONIAS & ALLIES

Cool FACT

House Finches feed their nestlings exclusively on plant foods, a fairly rare occurrence in the bird world. Many birds that are vegetarians as adults nevertheless seek animal foods to keep their fast-growing young supplied with protein.

CASSIN'S FINCH

Slightly less well known than its look-alikes—the House Finch (page 334) and Purple Finch—this is the characteristic, rosy-tinged finch of the mountains of western North America. Small flocks twitter and forage in the tall evergreen forests and in groves of quaking aspen. Along with its range and habitat, a good way to confirm an ID is to learn the peaked head shape and thick, straight-edged bill of the Cassin's Finch. Males sing a rollicking song that includes mimicked calls of other birds.

The Cassin's Finch was first collected on an 1850s expedition to the southwestern mountains by the Pacific Railroad Survey. The eminent ornithologist John Cassin, who created illustrations for the survey, called the pink-tinged finch the "greatest bird in the lot." Spencer Baird, a fellow ornithologist and the first curator of the Smithsonian Institution, named the bird after Cassin.

Haemorhous cassinii

ORDER

PASSERIFORMES

FAMILY

FRINGILLIDAE / FINCHES, EUPHONIAS & ALLIES

Cool **FACT**

The Cassin's Finch craves salt and is often found visiting mineral deposits on the ground.

RED CROSSBILL

A fascinating finch of coniferous woodlands in both hemispheres, the Red Crossbill forages on nutritious seeds extracted from the cones of pine, hemlock, Douglas fir, and spruce. Its specialized bill enables it to break into unopened cones, giving it an advantage over other finch species. Because conifers produce seeds unpredictably, Red Crossbills sometimes wander (or *irrupt*) far beyond their usual range.

They nest wherever and whenever they find abundant food, sometimes even in winter. Several types of Red Crossbill exist; they each have different calls and feed on particular conifer species. The different types wander widely and sometimes join up with other crossbill types, but because they don't tend to interbreed, they might eventually be sorted into distinct species.

Loxia curvirostra	**ORDER** **PASSERIFORMES**	**FAMILY** **FRINGILLIDAE / FINCHES, EUPHONIAS & ALLIES**

Cool **FACT**

The Red Crossbill is so dependent upon conifer seeds that it even feeds them to its young. Consequently, it can breed anytime it finds a sufficiently large cone crop, even in the depths of winter.

PINE SISKIN

Flocks of tiny Pine Siskins may monopolize your thistle feeder one winter and be absent the next. This nomadic finch ranges widely and erratically across the continent each winter in response to seed crops. Better suited to clinging to branch tips than to hopping along the ground, these brown-streaked acrobats flash yellow wing markings as they flutter while feeding, or as they explode into flight.

Siskins are gregarious, and you may hear a flock's insistent wheezy twitters before you see them. Also listen for a distinctive, harsh "watch-winding" call, which some liken to the sound of slowly tearing a sheet of paper in two, amidst their constant flock twitters.

Spinus pinus	**ORDER** PASSERIFORMES	**FAMILY** FRINGILLIDAE / FINCHES, EUPHONIAS & ALLIES

Cool FACT

Pine Siskins get through cold nights by ramping up their metabolic rate—typically to 40 percent higher than most songbirds of their size. When temperatures plunge as low as minus ninety-four degrees F, they can accelerate that rate up to five times that of other birds for several hours. They also put on half again as much winter fat as their Common Redpoll and American Goldfinch (page 342) relatives.

AMERICAN GOLDFINCH

This handsome little finch—the state bird of New Jersey, Iowa, and Washington—is common and welcome at feeders, where it takes primarily sunflower and nyjer. Goldfinches often flock with Pine Siskins (page 340) and Common Redpolls. Spring males are brilliant yellow and shiny black with a bit of white. Females and all winter birds are a more drab brownish olive yet can be identified by their conical bill, pointed and notched tail, wingbars, and lack of streaking. During molts, they look bizarrely patchy.

The American Goldfinch is the only finch that molts its body feathers twice a year, once in late winter and again in late summer. The slowly brightening yellow of male goldfinches each spring is a welcome sign of approaching warm months.

Spinus tristis	**ORDER** **PASSERIFORMES**	**FAMILY** **FRINGILLIDAE / FINCHES, EUPHONIAS & ALLIES**

Cool FACT

Goldfinches are among the strictest vegetarians in the bird world, consuming an entirely vegetable diet and only inadvertently swallowing an occasional insect.

AFTERWORD

THE ORIGIN STORY OF THE ART: At a convention in mid-2016, I sat down for a brief conversation that would lead to a bestselling, award-winning bird game, several new careers, and the art that you're enjoying in the pages of this book.

The conversation was with game designer Elizabeth Hargrave. I'm a game designer, too, but just then I was wearing my publisher hat. I was at Gen Con (North America's largest tabletop-game convention) looking for a new game for my company, Stonemaier Games.

The game Elizabeth pitched to me would change quite a bit over the next few years before it was published as Wingspan. But even at that early stage, I was really impressed by the nearly one hundred unique bird cards Elizabeth had designed, each with mechanisms that reflected the beautiful oddities of our feathered friends.

After we signed the game and began to develop it with Elizabeth, I needed to find an artist who could illustrate the 170 birds that would eventually appear in the core game (later to be joined by ten "promo birds" and eighty-one European birds). My business partner mentioned that the parent of one of his kid's school friends was a self-taught nature artist. As soon as I saw Natalia's artistic style and precision, I knew she would be perfect for the birds of Wingspan, so I reached out to her to discuss the project. Until then, she had worked on only a few commissioned illustrations, but she was eager to take on the challenge.

Natalia would eventually bring her friend Ana on to the creative team, and it's been a pleasure to commission hundreds of birds from them since that time. Just as I've been incredibly happy to see Elizabeth become, after Wingspan's success, one of the most sought-after game designers in the industry, I'm elated that Natalia and Ana have received such widespread recognition for their work, resulting in exciting opportunities like selling art prints on their websites and contributing their bird illustrations to this book.

It's been a joy to see the birds spring to life on the table, thanks to the design and the artwork. I hope you enjoy the stories of the birds and the art you'll find on these pages. If you want to delve deeper into the world of Wingspan, I invite you to try out the game, in either tabletop or digital form.

—Jamey Stegmaier, Stonemaier Games

LEARN MORE ABOUT BIRDS
with the Cornell Lab of Ornithology

Birds offer a lifetime of joy and inspiration. Here are more ways to learn about birds, beautify your surroundings, and contribute to a healthier planet.

1. See how many new birds you can identify with help from the free Merlin Bird ID app. By asking you three simple questions about a bird you're trying to identify, Merlin shows you which birds you're most likely to see based on your location and time of year. Merlin. AllAboutBirds.org

2. Delve into a wealth of information available free at the All About Birds website. Explore fascinating facts, sounds, photos, range maps, and birdwatching tips. AllAboutBirds.org

3. Build your knowledge and skills with quizzes, online games, and distance-learning courses found at Bird Academy. Courses are taught by the Cornell Lab of Ornithology's experts and guest experts; topics include nature journaling, photography, bird identification, the joy of birdwatching, and more. Academy. AllAboutBirds.org

4. Share and track your bird observations as part of a citizen science project. You can contribute to science and conservation by joining a project that matches your interests: eBird or the Great Backyard Bird Count, to record sightings and photos; NestWatch, to monitor the family lives of birds; Project FeederWatch, to study birds at your feeders; or Celebrate Urban Birds, to connect with birds in cities. Birds. Cornell.edu/citizenscience

5. Donate to your local land trust and support nonprofit organizations that protect nature. Enjoy and support parks and natural areas. Habitat loss and degradation is the number-one reason why birds are vanishing across the hemisphere.

6. Join the Cornell Lab of Ornithology to embark on a lifelong journey with birds. Get inspiration with the Lab's free eNewsletter or become a member to receive the beautiful *Living Bird* magazine. Birds.Cornell.edu/Join

ALPHABETIZED BIRDS

All birds marked with 🥚 were drawn by Natalia Rojas.
All birds marked with 🥚 were drawn by Ana María Martínez.

Bird		Page	Bird		Page
Acorn Woodpecker		170	Barn Swallow		224
American Avocet		114	Barred Owl		153
American Bittern		64	Barrow's Goldeneye		32
American Coot		106	Bell's Vireo		200
American Crow		210	Belted Kingfisher		166
American Goldfinch		342	Bewick's Wren		244
American Kestrel		182	Black-bellied Whistling-Duck		18
American Oystercatcher		116	Black-billed Magpie		206
American Redstart		274	Black-chinned Hummingbird		162
American Robin		256	Black-crowned Night-Heron		72
American White Pelican		60	Black-necked Stilt		112
American Woodcock		120	Black Skimmer		134
Anhinga		58	Black Tern		130
Anna's Hummingbird		164	Black Vulture		78
Ash-throated Flycatcher		190	Blue Grosbeak		308
Atlantic Puffin		126	Blue Jay		204
Baird's Sparrow		288	Blue-gray Gnatcatcher		246
Bald Eagle		92	Blue-winged Warbler		268
Baltimore Oriole		332	Bobolink		318
Barn Owl		144	Brant		20

Brewer's Blackbird		326	Common Merganser		36	
Broad-winged Hawk		96	Common Nighthawk		154	
Bronzed Cowbird		330	Common Raven		214	
Brown Pelican		62	Common Yellowthroat		272	
Brown-headed Cowbird		331	Cooper's Hawk		90	
Burrowing Owl		150	Dark-eyed Junco		292	
Bushtit		232	Dickcissel		316	
California Condor		80	Double-crested Cormorant		56	
California Quail		42	Downy Woodpecker		176	
Canada Goose		22	Eastern Bluebird		250	
Canvasback		30	Eastern Kingbird		194	
Carolina Chickadee		226	Eastern Phoebe		186	
Carolina Wren		243	Eastern Screech-Owl		146	
Cassin's Finch		336	Ferruginous Hawk		101	
Cassin's Sparrow		284	Fish Crow		212	
Cedar Waxwing		264	Forster's Tern		132	
Cerulean Warbler		276	Franklin's Gull		128	
Chestnut-collared Longspur		266	Golden Eagle		84	
Chihuahuan Raven		213	Grasshopper Sparrow		286	
Chimney Swift		156	Gray Catbird		258	
Chipping Sparrow		290	Great Blue Heron		66	
Clark's Grebe		52	Great Crested Flycatcher		192	
Clark's Nutcracker		208	Great Egret		68	
Common Grackle		328	Great Horned Owl		148	
Common Loon		50	Greater Prairie-Chicken		46	

Greater Roadrunner		140	Northern Cardinal		304
Green Heron		70	Northern Flicker		180
Hermit Thrush		254	Northern Harrier		88
Hooded Merganser		34	Northern Mockingbird		260
Hooded Warbler		273	Northern Shoveler		29
Horned Lark		216	Osprey		82
House Finch		334	Painted Bunting		314
House Wren		240	Painted Redstart		280
Inca Dove		136	Peregrine Falcon		184
Indigo Bunting		312	Pied-billed Grebe		51
Juniper Titmouse		230	Pileated Woodpecker		181
Killdeer		118	Pine Siskin		340
King Rail		102	Prothonotary Warbler		270
Lazuli Bunting		310	Purple Gallinule		104
Lincoln's Sparrow		299	Purple Martin		218
Loggerhead Shrike		198	Pygmy Nuthatch		238
Mallard		28	Red Crossbill		338
Marsh Wren		242	Red-bellied Woodpecker		172
Mississippi Kite		86	Red-breasted Merganser		38
Mountain Bluebird		252	Red-breasted Nuthatch		234
Mountain Chickadee		228	Red-cockaded Woodpecker		178
Mourning Dove		138	Red-eyed Vireo		201
Northern Bobwhite		44	Red-headed Woodpecker		168

Red-shouldered Hawk		94		Trumpeter Swan		24
Red-tailed Hawk		100		Tufted Titmouse		231
Red-winged Blackbird		320		Turkey Vulture		79
Ring-billed Gull		129		Vaux's Swift		157
Roseate Spoonbill		76		Violet-green Swallow		222
Rose-breasted Grosbeak		306		Western Meadowlark		322
Ruby-crowned Kinglet		248		Western Tanager		302
Ruby-throated Hummingbird		160		White-breasted Nuthatch		236
Ruddy Duck		39		White-crowned Sparrow		294
Sandhill Crane		108		White-faced Ibis		74
Savannah Sparrow		296		White-throated Swift		158
Say's Phoebe		188		Whooping Crane		110
Scaled Quail		40		Wild Turkey		48
Scissor-tailed Flycatcher		196		Willet		124
Snowy Egret		69		Wilson's Snipe		119
Song Sparrow		298		Wood Duck		26
Spotted Owl		152		Wood Stork		54
Spotted Sandpiper		122		Yellow-bellied Sapsucker		174
Spotted Towhee		300		Yellow-billed Cuckoo		142
Sprague's Pipit		262		Yellow-breasted Chat		282
Steller's Jay		202		Yellow-headed Blackbird		324
Swainson's Hawk		98		Yellow-rumped Warbler		278
Tree Swallow		220				

ACKNOWLEDGMENTS

Publishing this book is a dream come true, and it wouldn't have been possible without Jamey Stegmaier and Stonemaier Games, who opened up their doors and gave us the honor to create the illustrations for Wingspan when we had no previous experience in creating art for board games. We are eternally grateful to Alan Stone and Erin Maloney for their friendship and noticing the potential in our artwork. We'd also like to extend a special thanks to Elizabeth Hargrave for her role in this book, in Wingspan, and for guiding us through the image-selection process.

We are forever grateful to our families for their unconditional love and support during the long hours it took to draw these birds. To the Martínez family for their hospitality and encouragement; thank you Margarita, Catalina, and Luis Mario; and thanks to the Arias-Gómez family for being our biggest fans. Many thanks to Maria Consuelo Gómez, Andrés, Lucía, and Elena Arias for their loving patience and adaptability. We are thankful to have you in our lives.

To the creative development team at HarperCollins Publishers who gave us the incredible opportunity to publish our first book; thank you. Thanks to Lisa Sharkey and Maddie Pillari for guiding us through this process. We cannot thank you enough for trusting in our talent to create the book cover, endpapers, and self-portraits. Thank you to everyone on the Harper Design team, especially Marta Schooler, Lynne Yeamans, Dori Carlson, Stacey Fischkelta, and Laura Palese. A special thanks to Professor Joseph Schraibman from Washington University in St. Louis, who generously translated our words in our introduction from Spanish to English. Working with a publisher like HarperCollins has been wonderful, and having your trust means a lot. We are so grateful for your warm welcome and kindness to us throughout the entire process of this book.

We are also immensely grateful to the photographers who kindly allowed us to use the most incredible photos as references for our drawings. To Alan Murphy, Glenn Bartley, Roman Brewka, Rob Palmer, and Peter Green, thank you for providing the inspiration for our birds.

Thank you to Miyoko Chu and the Cornell Lab of Ornithology for providing the beautiful text for the illustrations in this book, and for everything the Lab does as an advocate for the natural world and a resource for the birding community.

Lastly, many thanks to the Wingspan, board games, and birding communities

for welcoming our work with such enthusiasm and support. We are humbly grateful to every person who has supported our careers by purchasing prints, original illustrations, and liking and commenting about the art on Wingspan. To all of you, many thanks!

ABOUT THE ARTISTS

NATALIA ROJAS: As a somewhat introverted child, I loved writing and drawing imaginary worlds. I never imagined that my passion and talent would be more than a hobby. As an adult, I found myself generally unsatisfied with my career path. I first moved from Colombia to Costa Rica in 2005, where I worked as a financial assistant. My life changed dramatically in 2012, when my husband, Andrés was transferred for work and we moved to Bentonville, Arkansas. Aside from my husband and eight-month-old daughter, Lucia, I was alone, with no friends or extended family. I felt trapped.

I knew I had to make a change, and so I joined Studio 7, a local art studio in Bentonville, as an attempt to find a community. There, I discovered my enduring passion for art and decided to pursue the call of my heart and find a career as an artist. I now live in Tampa with my husband and daughters, Lucia and Elena, and continue to work full-time as an artist. https://nataliarojasart.com/

ANA MARÍA MARTÍNEZ: When I was a child, I loved to draw. I especially loved drawing Disney characters, and drew anime and manga all the time. After graduating from high school in 2002, I didn't know what to study because I liked too many things. I loved all my subjects: biology, history, engineering, design, the arts. At first, I decided to focus on bioengineering, but I quickly realized that this field wasn't for me, and my real passion was to be an artist. In 2004, I began to study fine arts at the University of Antioquia and I graduated in 2010.

After graduating, I taught art for three years. I started to work in early childhood education as a workshop facilitator. In this role, I became particularly interested in how important art was for children's development. I joined a childhood studies masters program at University of Antioquia. In order to pay for my classes and complete my masters degree, I founded Nature Canvas, a company specializing in drawing animals, pets, and nature. Through Nature Canvas, I reconnected with Natalia and together, we embarked on our Wingspan adventure, and my career as an artist took flight. I now live with my parents and sister in Medellín, Colombia. https://www.anammartinez.com/

CELEBRATING BIRDS

Designed by Laura Palese

First published in 2021 by Harper Design

An Imprint of HarperCollinsPublishers
195 Broadway
New York, NY 10007
Tel: (212) 207-7000
Fax: (855) 746-6023
harperdesign@harpercollins.com
www.hc.com

Distributed throughout the world by HarperCollinsPublishers
195 Broadway
New York, NY 10007

ISBN 978-0-06-304574-3

Library of Congress Control Number: 2020043114

Printed in Korea

First Printing, 2021